IMAGES
of America

SAN FRANCISCO'S
CASTRO

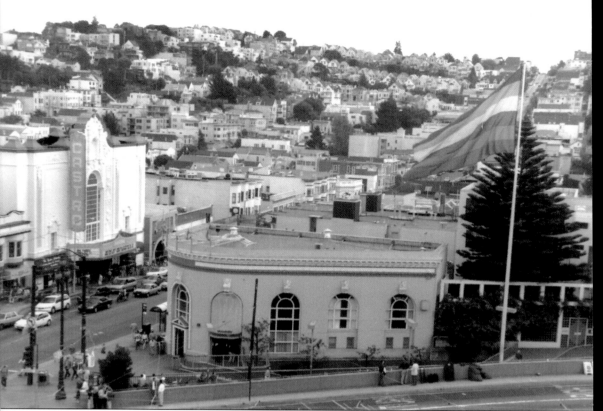

This overview, looking south with San Francisco's downtown to the left, shows the Castro Theatre on the left, the old Bank of America in the foreground, and Harvey Milk Plaza and the Rainbow Flag. (Photo Rick Gerharter.)

On the cover: Harvey Milk walks with his friends from the Castro to City Hall on January 9, 1978, to be sworn in as a San Francisco supervisor. He is the first openly gay person to hold major public office in California. (Photo Daniel Nicoletta.)

IMAGES
of America

SAN FRANCISCO'S
CASTRO

Strange de Jim

ARCADIA
PUBLISHING

Published by Arcadia Publishing
Charleston, South Carolina

Printed in the United States of America

Library of Congress Catalog Card Number: 2003112431

For all general information contact Arcadia Publishing at:
Telephone 843-853-2070
Fax 843-853-0044
E-Mail sales@arcadiapublishing.com
For customer service and orders:
Toll-Free 1-888-313-2665

Visit us on the Internet at www.arcadiapublishing.com

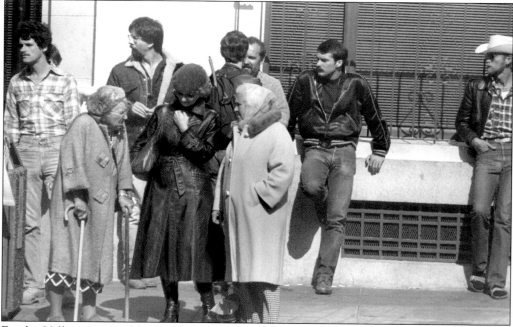

Eureka Valley is a neighborhood in transition in the early 1970s. (Photo Crawford Barton, courtesy Gay, Lesbian, Bisexual, Transgender (GLBT) Historical Society.)

CONTENTS

ACKNOWLEDGMENTS

Thanks to Pride Foundation award-winning photographer Dan Nicoletta, one of the people closest to Harvey Milk, for taking me under his wing. Rink Foto brought his best work for me to choose from, as did Bob Meslinsky, Janis Greenberg, James Kennedy, and Derrick Tynan Connolly. Photographer Rick Gerharter spent two days with me going through his files of photos. Harvey Milk's associates Allan Baird, Tory Hartmann, and John Ryckman generously shared their experiences with Harvey.

Thanks go to many fine folks at Most Holy Redeemer Church, especially Father Donal Godfrey, who shared his doctoral dissertation on the integration of gays into Most Holy Redeemer. Mahmood Ghazi of Café Flore and Martha Asten at Cliff's Variety were of great help, as were Tim Wilson at the James C. Hormel Gay & Lesbian Center of the San Francisco Public Library and Kim Klausner at the Gay Lesbian Bisexual Transgender Historical Society. Thanks to Dennis Peron, Jack Fertig (Sister Boom-Boom), and Michael Mullin. Thanks to society pianist Peter Mintun for introducing me to Todd Trexler, and to my roommate, Stephen Pullis, for putting up with me.

I found *Out in the Castro* by Winston Leyland and *The Mayor of Castro Street: The Life and Times of Harvey Milk* by Randy Shilts extremely helpful. Other good sources were *Gay by the Bay* by Susan Stryker and Jim Van Buskirk, *Stitching a Revolution* by Cleve Jones, *Cities on a Hill* by Frances FitzGerald, *Long Road to Freedom: The Advocate History of the Gay and Lesbian Movement*, and *The St. James Press Gay & Lesbian Almanac*. The movies *The Times of Harvey Milk* and *The Cockettes* were treasure troves of information, as were KQED documentaries on the Castro and Harry Hay.

Finally, I'm grateful to Bruce Bellingham, lead columnist of the *San Francisco Examiner* (a fellow I call "Saint Bruce") for suggesting me to editor John Poultney at Arcadia Publishing, who did a great job of steering me through the process.

I have so many links to Castro web sites and other things I'd love to share with you. Please visit me just off the web at http://members.aol.com/strangecastro/.

INTRODUCTION

In these 200-odd photographs you are about to see exactly how a quiet Irish Catholic neighborhood suddenly added "World's Gay Mecca" to its list of attractions. You'll watch people who seem to be opposites learning to live in harmony. Whether you use this knowledge to bring about world peace is entirely up to you.

For thousands of years the land surrounding San Francisco Bay was sunny grassland inhabited by rabbits, geese, ducks, deer, wolves, mountain lions, and the Ohlone Tribe. The Spanish de Anza Expedition in 1776 found sites for the Presidio military camp and Mission Dolores. What is now the corner of Castro and Market Streets was once an intersection of the trails between these two locations and existing Indian trails. Castro Street was named for Joaquin Isidro de Castro, a soldier with de Anza, whose grandson Jose Castro was a resistance fighter when the United States took California from Mexico in 1846. The Eureka Valley, which is now called the Castro, was part of the 4,000-acre Rancho San Miguel, owned by Jose de Jesus Noe, that extended from Twin Peaks to Daly City. His home was at what now would be Eureka and Twenty-second Streets. The creek that ran from Twin Peaks to the Bay still flows under Eighteenth Street today.

In 1849 gold was discovered at Sutter's Mill. By the end of the year the population of San Francisco had grown from 2,000 to 20,000. By 1850 it reached 34,000, almost all men. In the square dances held in bars, handkerchiefs were worn in the back pocket to distinguish those who were men from those who were portraying women. By the 1870s the rancho had become smaller farms, raising cattle, sheep, and vegetables. Then working-class European immigrants began moving into Eureka Valley and building Victorian homes for their large families. A steam dummy rail system from the Ferry Building at the downtown end of Market Street reached Castro and Market in the early 1880s, and this brought a surge of settlers. In 1887 a cable car replaced the steam dummies, and the line was extended down Castro Street and over the hill to Twenty-sixth Street in Noe Valley.

Most Holy Redeemer Catholic Church was consecrated in 1902. For many residents, Eureka Valley became Most Holy Redeemer Parish. The Catholic kids attended Most Holy Redeemer School, with the teaching nuns living in the convent next door. Other neighborhood kids

went to Douglass School at Nineteenth and Collingwood. The area was a regular blue-collar neighborhood, with many bars, whose patrons were almost all male. In the 1950s the American dream became a house in the suburbs, and many of the younger residents moved out. In the early 1960s San Francisco saw the loss of a huge number of blue-collar jobs, and that greatly sped the exodus. Property values plummeted, and many Castro Street businesses closed.

Meanwhile, other changes were taking place in San Francisco and society as a whole. San Francisco had always been a bawdy port city; it had been the debarkation point for the U.S. Navy in the Spanish-American War, World War II, and the Korean War. Sailors given dishonorable discharges for being homosexual often found themselves facing bleak prospects back in their hometowns, so they stayed in this relatively tolerant city.

America experienced a Civil Rights Movement and a Women's Movement. The Beats took over San Francisco's North Beach in the 1950s, and the hippies invaded Haight Ashbury, right across the hill from Eureka Valley, in the 1960s. In 1969 the Stonewall Riots in New York City heralded the start of the gay rights movement, which quickly spread across the country.

In 1963 a gay bar called the Missouri Mule opened on Market Street between Castro and Noe, followed by the Pendulum on Eighteenth Street a few years later. Attracted by the bars and the cheap rents, gay hippies began drifting over from the Haight. When gay people started moving in in droves . . . well, we'll just have to see the actual photos for ourselves.

One

1880–1960s

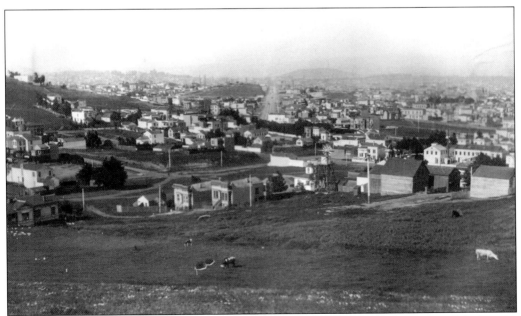

From what is now the intersection of Douglass and Caselli we see the built-up part of the Eureka Valley in 1880. Note the cows grazing. Market Street is running straight away from us in the center of the photo. All of the hillside behind the camera is bare.

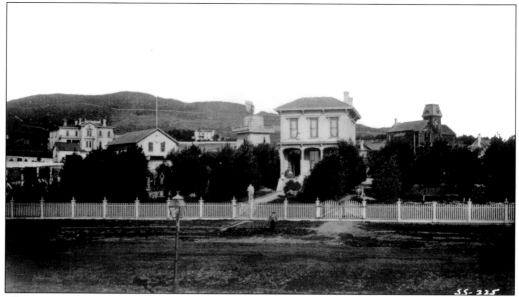

This is a view taken in the 1870s of Market Street between Noe and Sanchez. Public transportation has not yet reached the area.

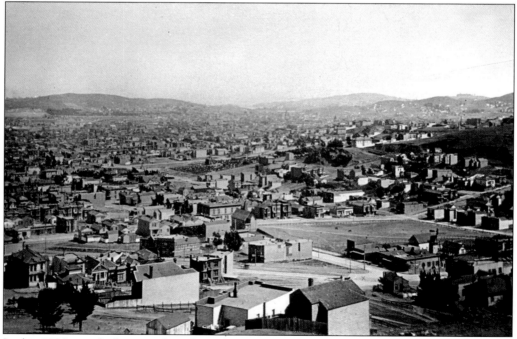

In this 1880 view looking south and east from Corona Heights, the main intersection of Castro, Market, and Seventeenth Streets is in the right foreground.

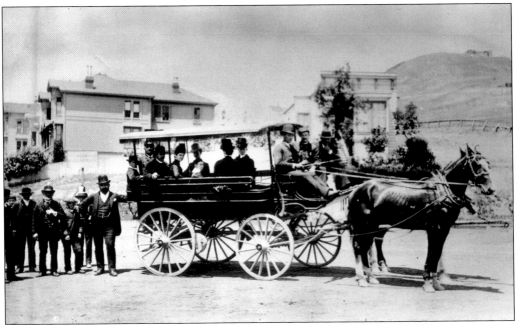

These folks are at Castro and Market *c.* 1885. In the upper right we can see that Corona Heights is a nice rounded hill, which has not yet been destroyed by the quarrying of the notorious Gray brothers.

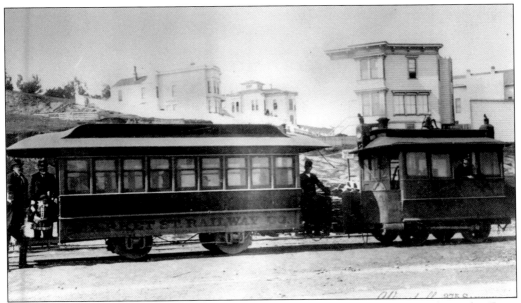

In the early 1880s these steam dummy vehicles reach Castro and Market from the Ferry Building at the other end of Market Street. The engine is in the little section, and the passengers ride in the bigger car. The advent of public transportation brings an influx of new residents.

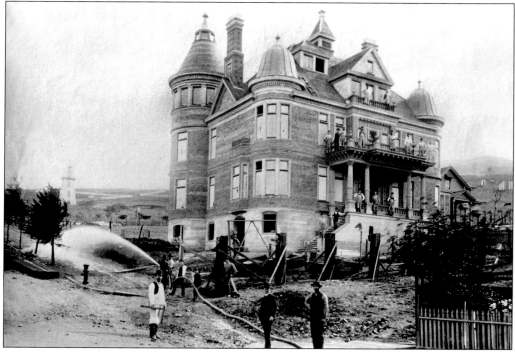

In 1892 wealthy "Nobby" Clarke builds a mansion at the corner of Douglass and Caselli. His friends make fun of him for living so far out in the boonies.

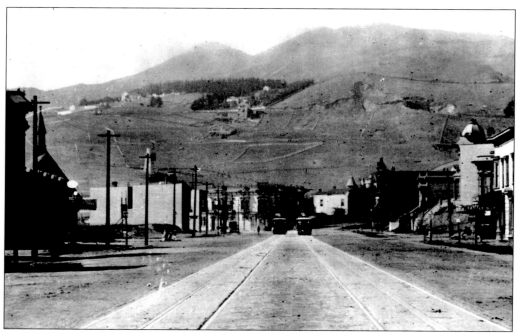

In 1895 Twin Peaks is still empty. This view looks west on Market Street.

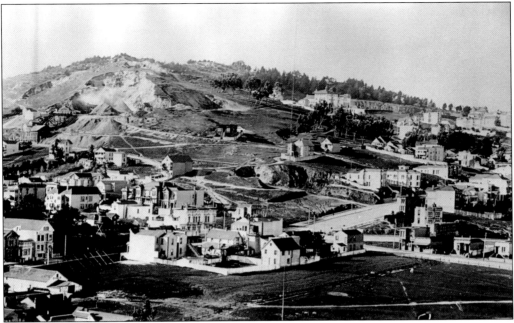

Corona Heights is in the upper left portion of this 1899 view from Dolores Heights. We can see that the Gray brothers have begun dynamiting said Heights.

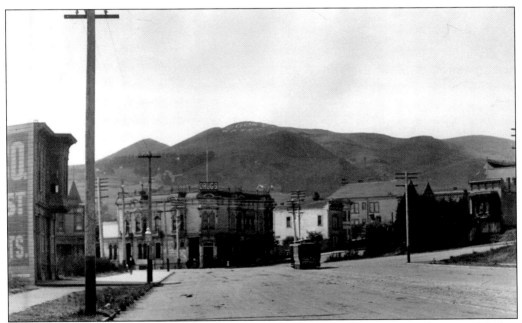

This is Castro and Market in 1900. In 1887 a cable car line, with the powerhouse at Market and Valencia, had replaced the steam dummies. The cable cars ran from the Ferry Building to this point, where they turn left and run on Castro all the way to Twenty-sixth Street in Noe Valley. That's a drug store straight ahead, on the corner of Castro and Market.

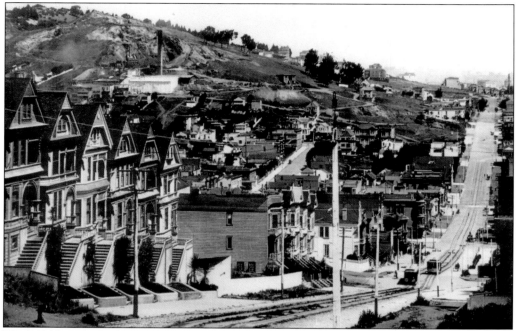

This 1900 view looks north from Castro and Twenty-first with cable cars going in each direction. Up on Corona Heights the Gray brothers' brick factory is under construction. It will make low-quality bricks, which will be used in the cable car beds and for some home construction. Check your chimneys.

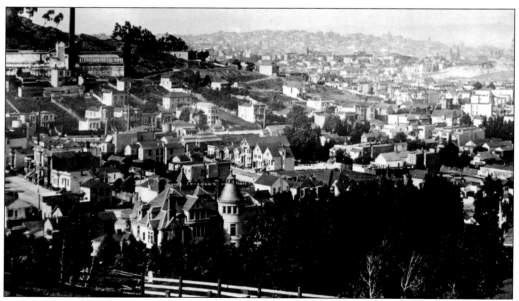

In this 1901 photo from behind Nobby Clarke's mansion we see the complete brick factory in the upper left. It survived until 1916 when the bankrupt Gray brothers' company closed. One of the Gray brothers was shot and killed by a disgruntled employee in another quarry the brothers ran at Castro and Thirtieth Street.

Most Holy Redeemer Church is consecrated in 1902 on Diamond at Eighteenth Street. Instead of Eureka Valley, many residents now begin saying they live in Most Holy Redeemer Parish. (Photo Most Holy Redeemer.)

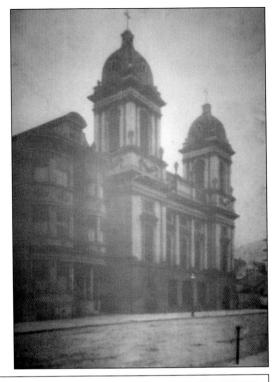

Rev. Joseph P. McQuaide
1900 - 05

Rev. Charles E. O'Neille
1917 - 32

Rt. Rev. Msgr.
William P. Sullivan
1932 - 48

Rt. Rev. Msgr. Henry J. Lyne
1948 - 68

Rev. John G. O'Connell
1968 - 76

Pastors of Most Holy Redeemer Parish

Rev. John M. Sweeney
Administrator, 1973 - 76

Rev. Donald E. Pyne
1976 - 79

Rev. Cuchulain K. Moriarty
1979 - 82

Rev. Anthony McGuire
1982 - 1990

Note: Rev. Patrick McGuire
1905-17 (No photo available)

It is the duty of pastors to preach God's word to all the Christian people so that rooted in faith, hope and charity, they may grow in Christ, and that the Christian community may bear witness to that charity which the Lord commended.
(Decree on the Bishop's Pastoral Office in the Church, 30.2)

June

Most Holy Redeemer Parish	Eucharist		Reconciliation
100 Diamond Street Hall: 621-9369	Saturday: 8:00 A.M. and 5:00 P.M.	Eves of Holy Days: 6:00 P.M.	Saturday: 3:30 til 5:00 P.M.
San Francisco. Support Group: 863-1581	Sunday: 7:30 and 10:00 A.M.	Holy Days: 8:00 A.M. and 6:00 P.M.	Sunday: 7:00 and 9:30 A.M.
California 94114 Senior Center: 863-3507	Weekdays: 8:00 A.M. and 6:00 P.M.		

Here are the pastors of Most Holy Redeemer from 1902 to 1990. (Photo Most Holy Redeemer.)

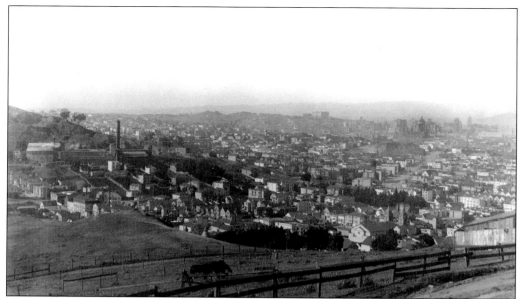

From what is now Kite Hill we can see after the 1906 earthquake that the downtown is all gone, except for the Fairmont Hotel, which we can see jutting up a little to the right of center. Eureka Valley suffers little damage in the quake and fire. However, the cable car power station at Market and Valencia is destroyed, and a new one has to be built at Castro and Jersey Streets in Noe Valley.

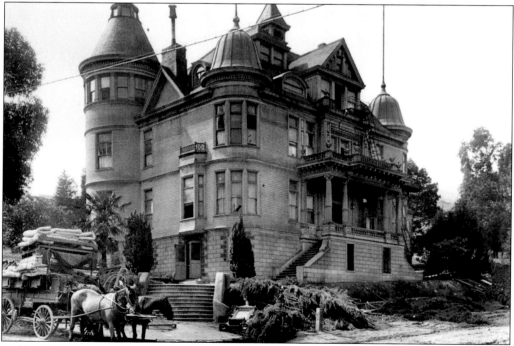

Nobby Clarke's mansion gives temporary refuge and medical help to earthquake victims.

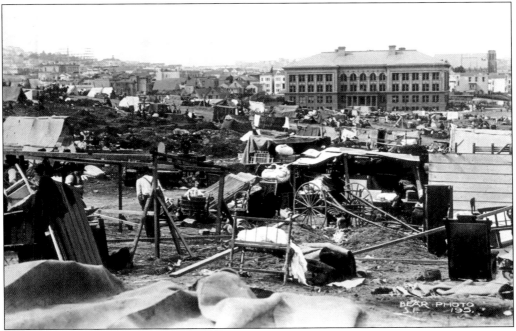

Dolores Park, four blocks east of Castro Street, fills with earthquake refugees. That's the old Mission High School on Eighteenth Street in the background.

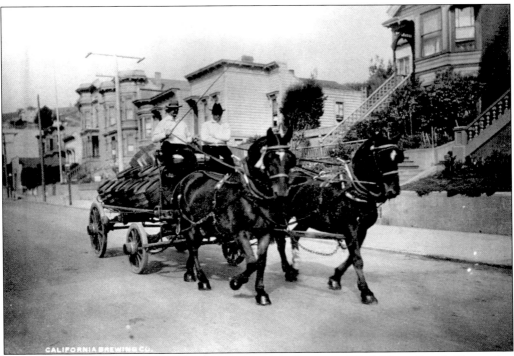

The rig that won first prize in the California Brewing Company Work Horse Parade September 9, 1909, trots up Seventeenth Street near Eureka.

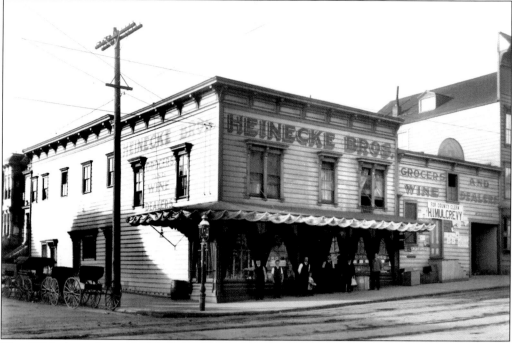

This 1909 photo shows the Heinecke Brothers Emporium on Eighteenth Street at Collingwood where Cala Foods is today.

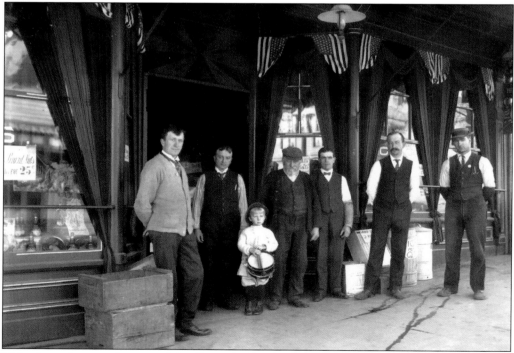

This photo shows a close-up of the Heinecke Brothers crew.

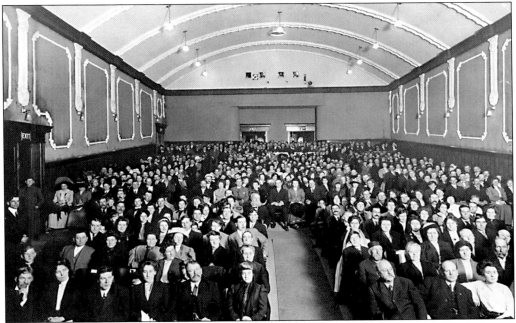

In 1910 the first Castro Theatre opens at 479 Castro Street between Eighteenth and Market, in the spot Cliff's Variety occupies today. From the expressions on the faces of the opening night audience, someone on the stage has just laid an egg.

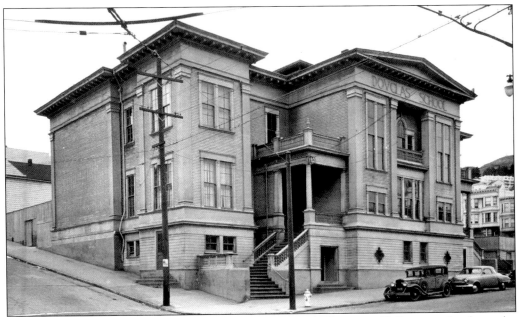

This is the Douglass Elementary School on Nineteenth Street at Collingwood, where the Harvey Milk Civil Rights Academy sits today. This building was torn down in 1953 when it couldn't meet earthquake standards. Note that the second S has fallen off of Douglass.

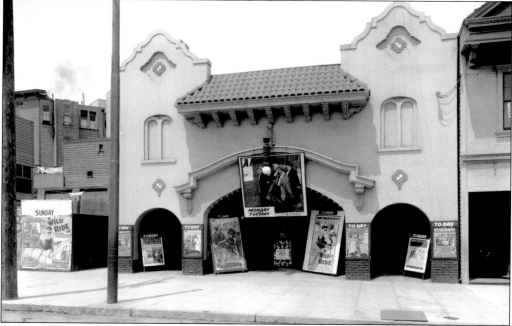

In 1913 the Jose Theater opens on the north side of Market Street in the building later occupied by the NAMES Project, which produces the AIDS Quilt.

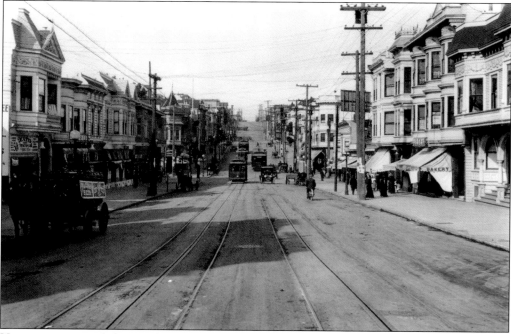

Here is a view of Castro Street in 1914, between Eighteenth and Nineteenth Streets, looking north to Market Street. Note that there are still some residences on the right.

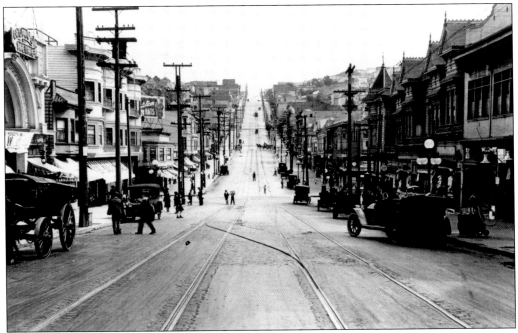

In this 1915 photo Market Street is behind the photographer as he or she looks south on Castro Street towards Noe Valley. The closest building visible on the left side of the street is the Castro Theatre.

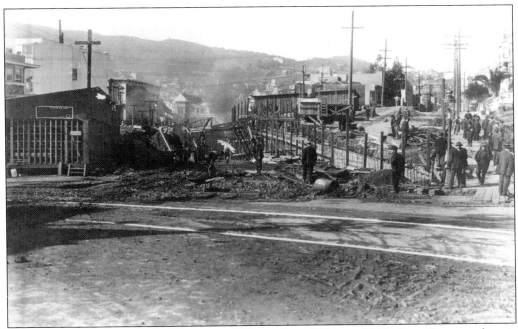

Construction on the Twin Peaks tunnel lasts from 1914 to 1917. It will carry electric streetcars to West Portal. This view looks up Seventeenth Street from Castro and Market.

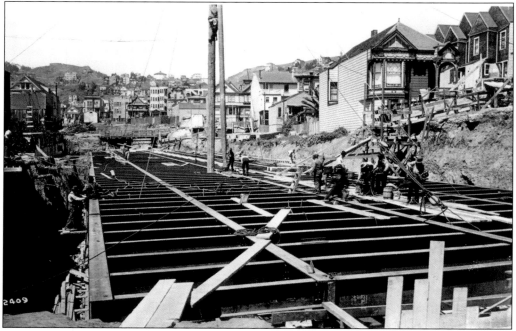

This is another image of the Twin Peaks tunnel under construction *c.* 1915. The photo was taken around Douglass Street.

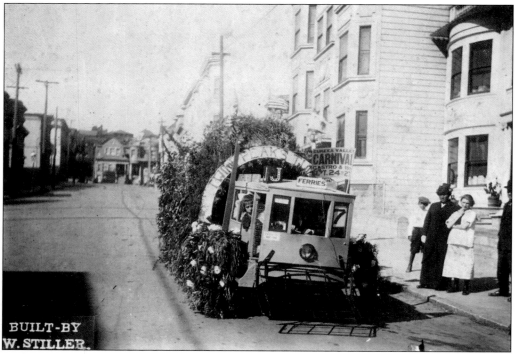

In this view the Twin Peaks tunnel is ready to open. A carnival is part of the 1917 celebration. This float is on Diamond near Eighteenth Street.

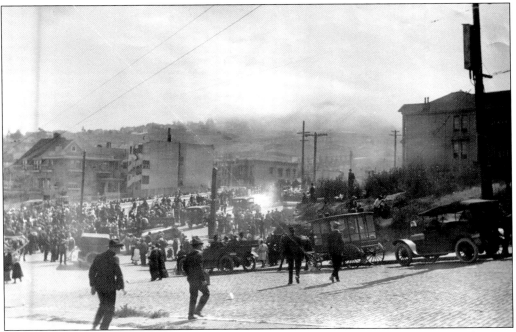

Crowds are flocking to the 1917 tunnel dedication. The camera is on the east side of Castro above Market.

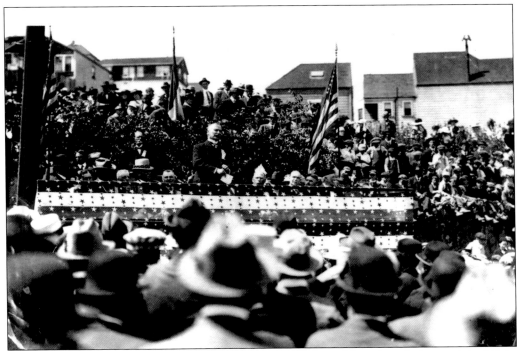

Chief Engineer O'Shaughnessy, who built not only the tunnel but the whole municipal light rail system, is the speaker at the big 1917 tunnel dedication.

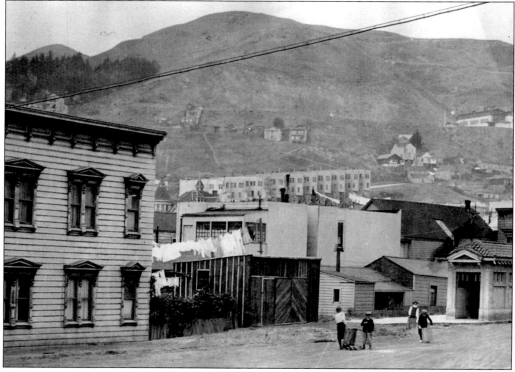

In the right foreground of this 1919 shot at Market and Diamond we can see the stairs that give pedestrian access to the Diamond Street Station.

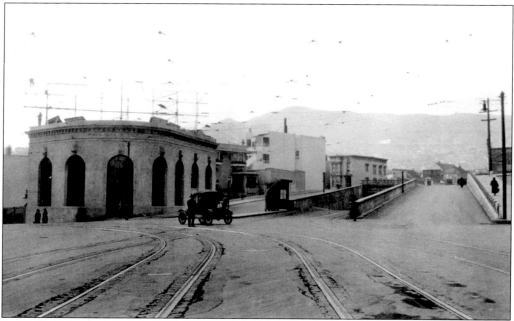

In 1920 the Twin Peaks tunnel and roadway are complete.

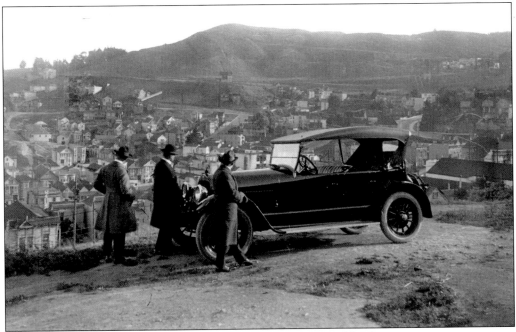

In 1922 these motorists are taking in the view from Corona Heights.

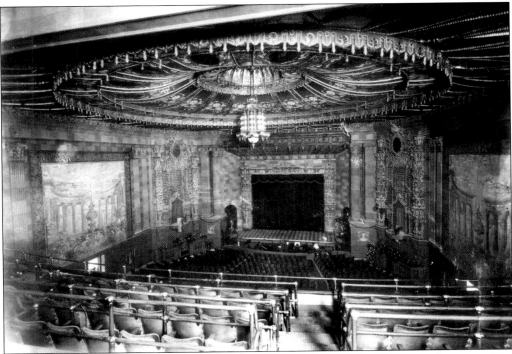

The big news in 1922 was the opening of the Castro Theatre at its present location. The theater was designed by the famous Timothy Pfleuger.

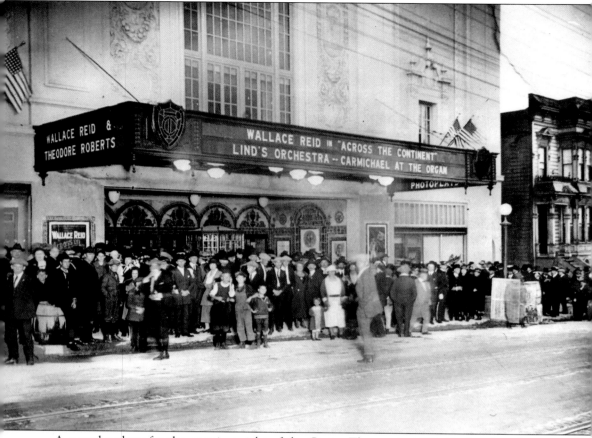

A crowd gathers for the opening night of the Castro Theatre in 1922. Notice that the giant vertical neon "CASTRO" sign has not yet been erected.

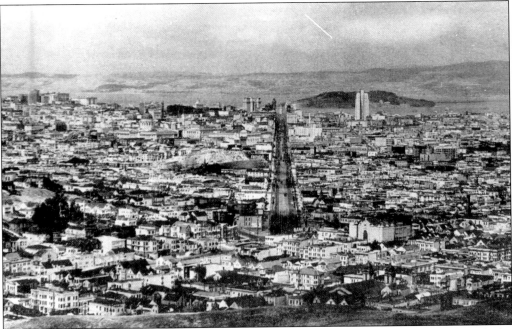

This 1927 shot shows the two Most Holy Redeemer towers in the right foreground, with the Castro Theatre just to the right of where Market Street makes a straight run to the Bay. The tall building in the right background is 140 New Montgomery. .

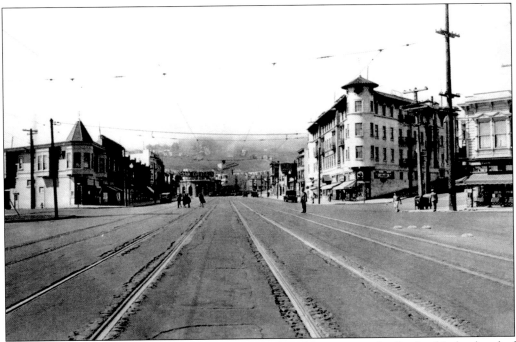

In this 1928 shot, looking west on Market Street from Noe, we see the Bank of Italy ahead of us on the left at Castro Street where the drug store used to be.

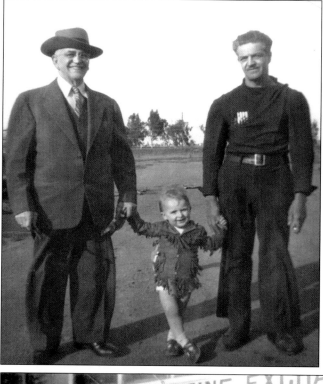

This 1948 photograph shows the three successive owners of Cliff's Variety, an institution on Castro Street since 1936. On the left is Hilario DeBaca. His son Ernie DeBaca is on the right. The child is Ernie's grandson Ernie Asten. He and his wife Martha are the present owners. The store was named after Hilario's son Clifford, who never worked there. (Photo Cliff's Variety.)

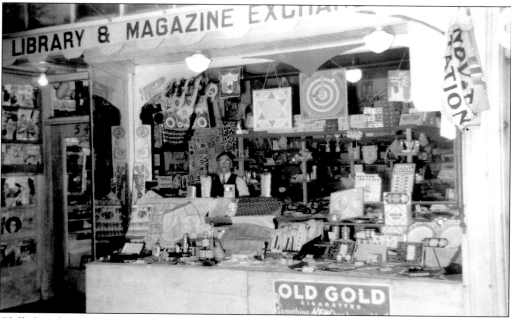

Cliff's has done business in four different locations on Castro Street. This first store at 545 Castro operated from 1936 to 1941. As you can see, it started out as a library and magazine exchange, selling candy and toys. Hilario DeBaca ran it at first. His son Ernie joined him and added his plumbing and hardware skills to what Cliff's could offer customers. (Photo Cliff's Variety.)

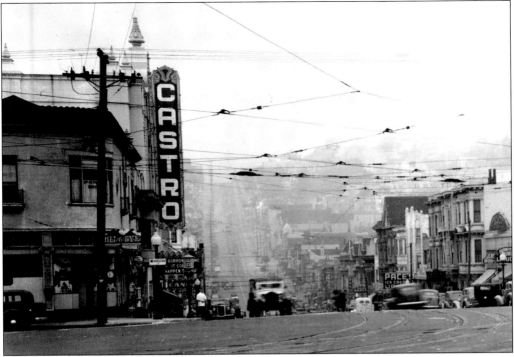

From Market Street we're looking south on Castro in 1939. On the corner on the left we see the Bill & Bye bar where the Twin Peaks bar is today.

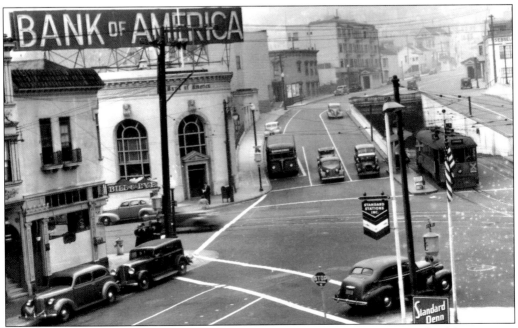

Also in 1939 we see that A.P. Giannini's Bank of Italy has been renamed Bank of America.

The Catholic kids in the neighborhood go to Most Holy Redeemer School on Diamond Street across the street from the church and rectory. To the left of the school we can see the convent where the nuns who taught in the school lived. (Photo Most Holy Redeemer.)

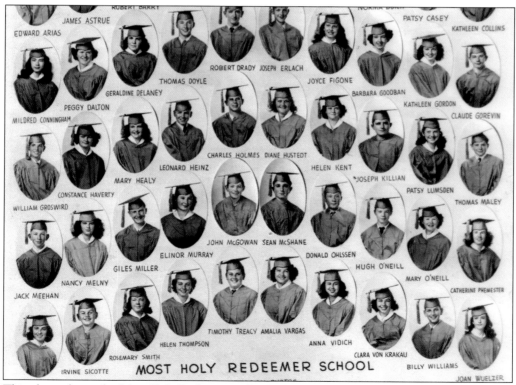

This photo shows the Most Holy Redeemer School Class of 1946. (Photo Most Holy Redeemer.)

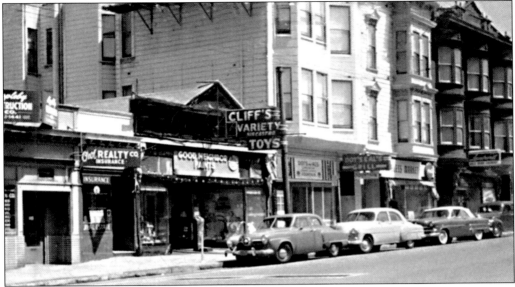

This is the second Cliff's Variety, which did business at 515 Castro from 1942 to 1960. Merchandise was stacked from floor to ceiling. (Photo Cliff's Variety.)

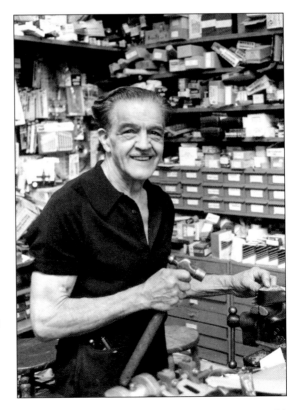

Ernie DeBaca became famous for charging very little for helping customers solve their plumbing and hardware problems. He was known to stay late at night to machine custom parts. He also took part in organizing neighborhood activities. (Photo Cliff's Variety.)

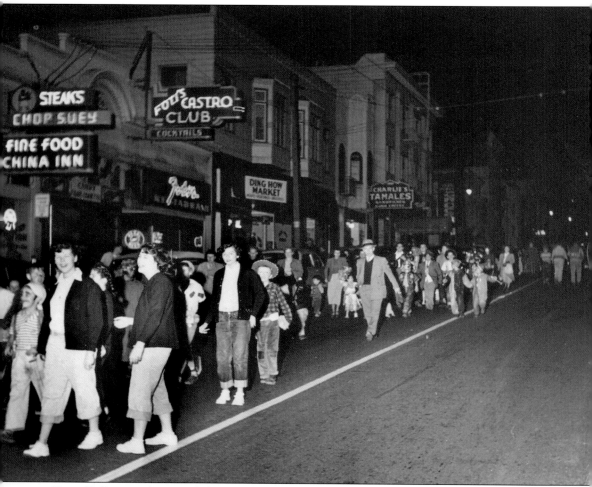

Ernie DeBaca took care of closing off the street for a children's Halloween parade every year, starting in 1946. The children's parade is still a feature of the neighborhood, though these days it's sponsored by the Sisters of Perpetual Indulgence. (Photo Cliff's Variety.)

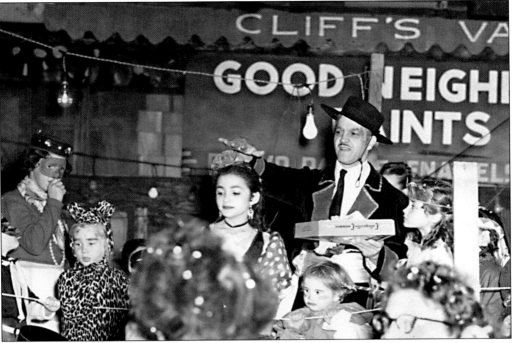

Ernie DeBaca judges a children's Halloween costume contest. (Photo Cliff's Variety.)

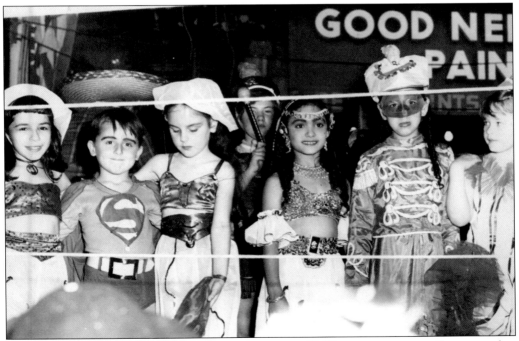

Here Ernie DeBaca's grandson Ernie Asten, the present Cliff's owner, appears as Superman, but he can't enter the contest, because his grandpa is judging. Ernie doesn't care; he's superman. (Photo Cliff's Variety.)

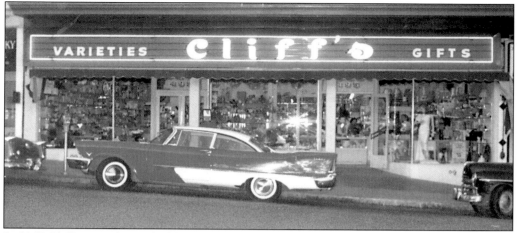

In 1960 Cliff's moved into the block between Eighteenth and Market. It operated at 495 Castro from 1960 to 1971. Merchandise again was piled from floor to ceiling and seemed to include everything you could find in a large department store. (Photo Cliff's Variety.)

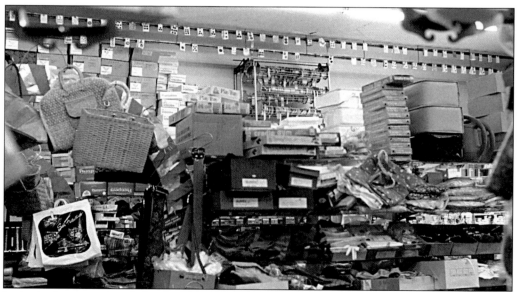

In both the second and third stores Ernie DeBaca built several chain conveyor apparatuses to allow customers at ground level to view merchandise stored near the ceiling. Here is the button machine. (Photo Cliff's Variety.)

Of course most merchandise had to be retrieved by hand. Here longtime employee Lena Sozzi scampers up a ladder like a mountain goat. (Photo Cliff's Variety.)

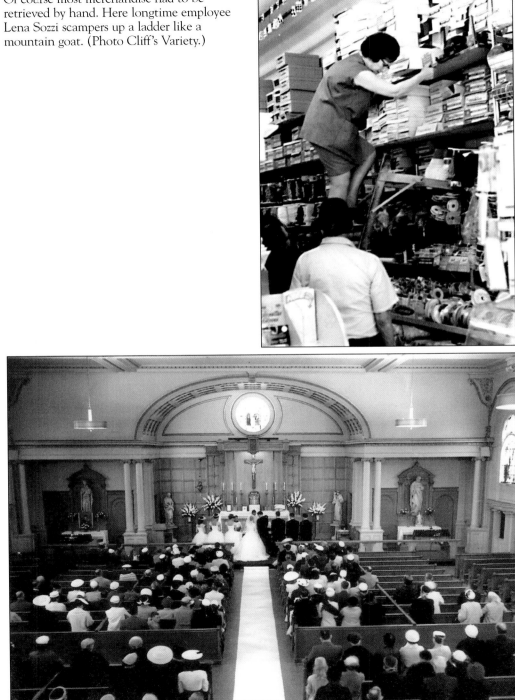

John and Evelyn Squeri were wed at the Most Holy Redeemer in 1956. Note how all the pews face the altar. (Photo John and Evelyn Squeri.)

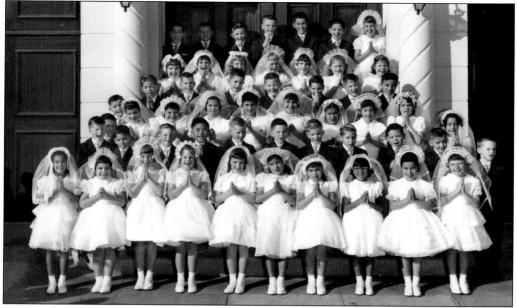

This photo shows the Most Holy Redeemer class of 1960. Who would have guessed what was about to happen to the neighborhood? In the next few years young families would move out of the area, either because they wanted to raise their kids in the suburbs or because blue-collar jobs in San Francisco were disappearing. Real estate values would fall, and businesses would close on Castro Street. (Photo Most Holy Redeemer.)

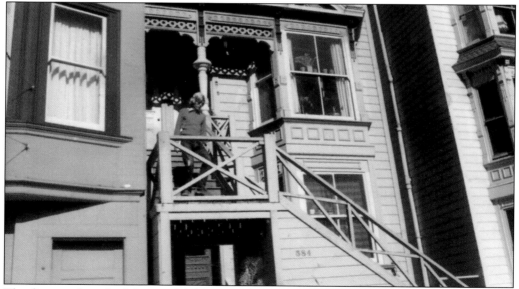

The first gay bar, the Missouri Mule, opened in 1963 at 2348 Market Street. Attracted by a gay bar and cheap rents, gay men started moving into the neighborhood. Among the first was Todd Trexler, shown here on the porch of 584B Castro, right across the street from what would become Harvey Milk's camera shop. Todd, an artist, opened the Peaches Dream Galleries. (Photo Todd Trexler.)

A poster for the Peaches Dream Galleries shows, from left to right, Roland Prijoles, Martin Izquierdo, and Todd Trexler. (Photo Todd Trexler.)

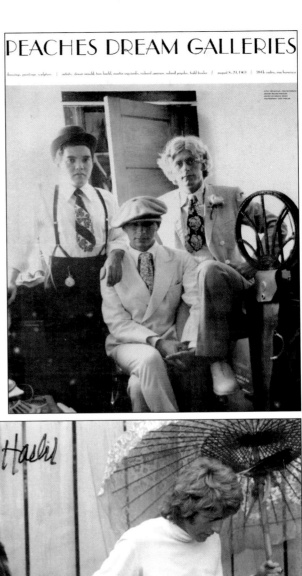

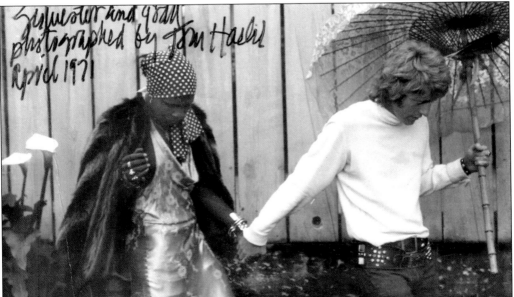

The Upper Market Street Gallery opened at 2323 Market Street, showing gay art. Todd exhibited there and became best friends with Sylvester and John Rothermel, two members of the Cockettes, a wild gender-bender troupe. Sylvester would go on to become a major disco star. Here are Todd and Sylvester in the backyard of Todd's apartment. (Photo Tom Haehl.)

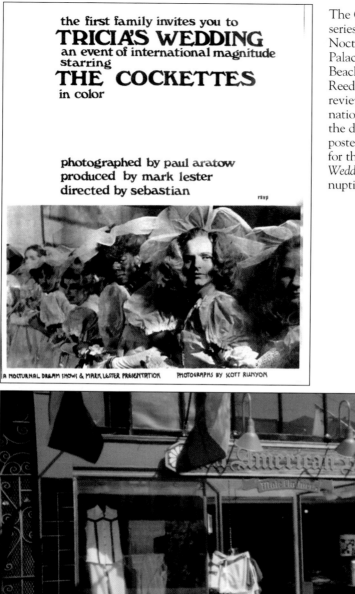

the first family invites you to

TRICIA'S WEDDING

an event of international magnitude
starring

THE COCKETTES

in color

photographed by paul aratow
produced by mark lester
directed by sebastian

rsvp

A NOCTURNAL DREAM SHOWS & MARK LESTER PRESENTATION PHOTOGRAPHS BY SCOTT RUNYON

The Cockettes began putting on a series of wildly popular midnight Nocturnal Dream Shows at the Palace movie theater in North Beach. Truman Capote and Rex Reed attended, and Rex wrote reviews that gained the troupe national attention. Todd became the designer of the Cockette's posters, for the live shows and for the movies, such as *Tricia's Wedding*, a spoof of Tricia Nixon's nuptials. (Photo Todd Trexler.)

Richard Lamb, once a dietary supply consultant for hospitals, opened a gay clothing store called The All American Boy, replacing the maternity shop. Todd Trexler designed the logo, signs, and advertisements. (Photo Strange de Jim.)

Two

1970s

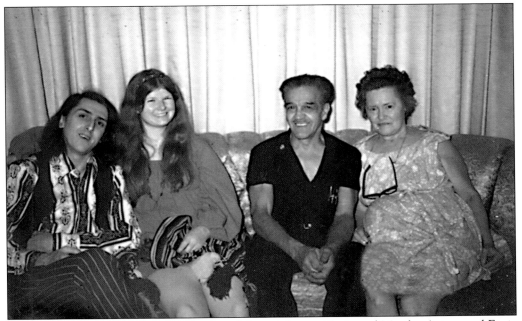

Cliff's Variety's owners in the 1970s, from left to right, are Ernie and Martha Asten, and Ernie and Alice DeBaca. They're about to move Cliff's once again. The first influx of gay men buying houses caused property values to plummet further. However, when gay men started restoring their old Victorians, with Cliff's help, property values shot up. (Photo Cliff's Variety.)

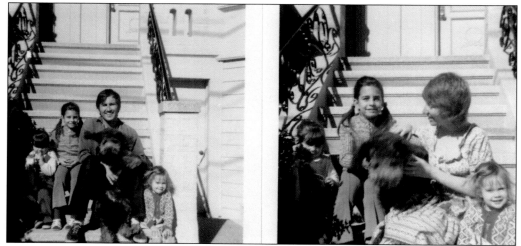

Real estate prices continued to rise. Here are two photos of Tory Hartmann and her husband Bill with some kids on the steps of the three-bedroom house they bought on Eighteenth Street in 1971 for $28,500. They'd sell it in 1976 for $150,000. Tory would become a close friend and supporter of Harvey Milk. (Photo Tory Hartmann.)

The landlord at 495 Castro told Ernie De Baca his rent was going to triple, believing Ernie would never move his mountains of merchandise. Ernie, however, knew that the Bon Omi Store was about to go out of business, so Ernie purchased the present site at 479 Castro, moved his business again, and spent the next two years digging out a full basement. (Photo Cliff's Variety.)

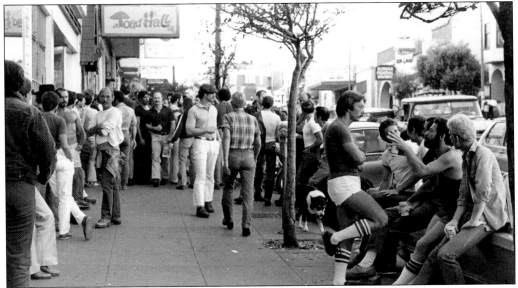

The neighborhood is certainly changing from Irish Catholic blue-collar families. Now on sunny days the streets are filled with young men. Toad Hall is a popular gay bar whose owner had wanted to call it The Iron Nun. The Catholic landlord, though willing to have a gay bar on the premises, was afraid that Most Holy Redeemer would object to the name. (Photo Crawford Barton, courtesy GLBT Historical Society.)

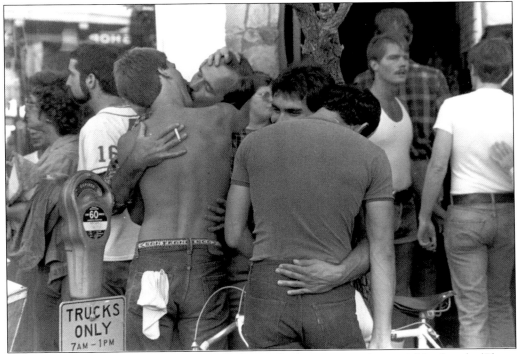

Scenes like these are certainly new to this and almost any other neighborhood. (Photo Crawford Barton, courtesy GLBT Historical Society.)

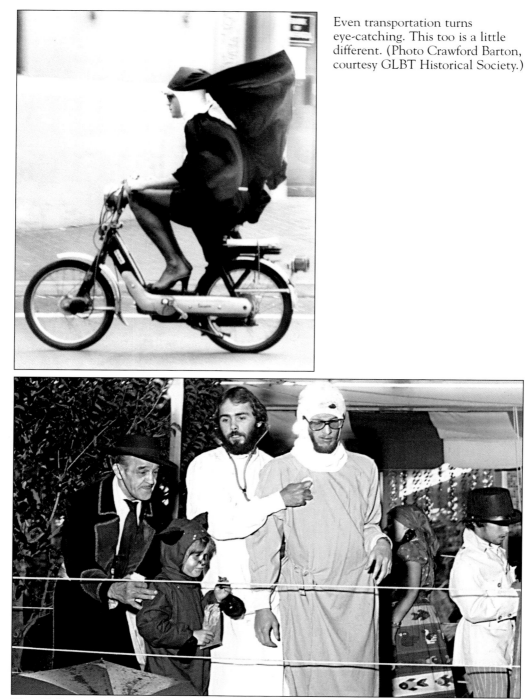

Even transportation turns eye-catching. This too is a little different. (Photo Crawford Barton, courtesy GLBT Historical Society.)

The Halloween costume contest now has adult contestants. Martha Asten says Ernie DeBaca was of the old-school, and that he was a little startled by the gay influx, but basically he was amused by it. She herself says, "There were the hippies and the gay guys. They were just people." (Photo Cliff's Variety.)

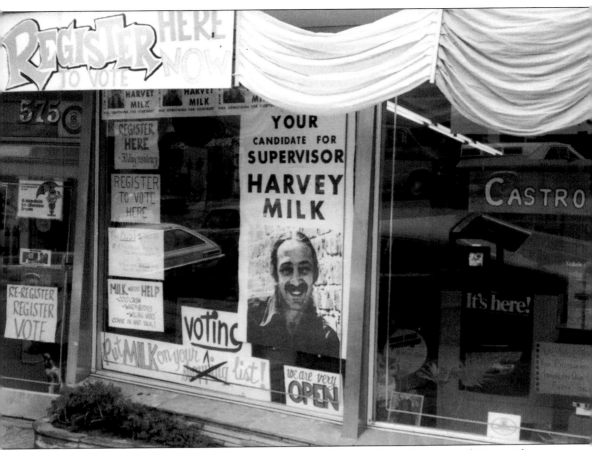

Harvey Milk was a conservative Republican on Wall Street, a closeted gay man living with a series of male lovers. Then he became involved with Tom O'Horgan, director of *Hair*, and turned into a hippie. In 1973 Harvey moved to San Francisco with his lover Scott Smith, and they opened Castro Camera. Very gregarious, Harvey introduced himself to all the other merchants, impressing them by not trying to sell them cameras. Soon everyone from gay teens to little old ladies began coming into his store to talk about their problems, which Harvey loved trying to solve. He soon became the unofficial "Mayor of Castro Street." Harvey supported all residents, even buying an ad for Castro Camera every week in the Most Holy Redeemer bulletin. When he discovered that the Eureka Valley Merchants Association wouldn't admit gay members, Harvey joined with the nice folks at Cliff's to start the rival Castro Village Association, which held the first Castro Street Fair in 1974, attracting 5,000 visitors. All the merchants on the street reported record sales. Upset by his own problems with the city government, Harvey decided to run for the board of supervisors in 1973. He lost, but found that he loved campaigning. (Photo Harvey Milk Archives, Scott Smith Collection, San Francisco Public Library.)

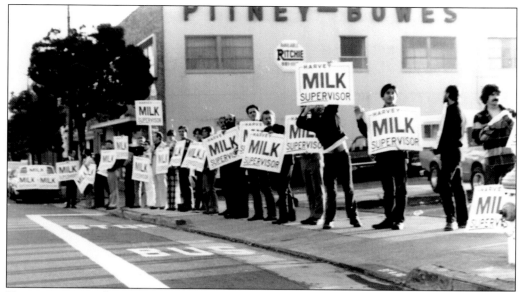

Harvey ran again for supervisor in 1975 and for state assembly in 1976. He lost both times, but garnered an impressive number of votes. He went out in the morning and talked with voters at bus stops. He attended every meeting where candidates were allowed to speak. He had a genius for grabbing voter and media attention. Here is his human billboard on Market Street, catching the morning commuters. (Photo Leland Toy.)

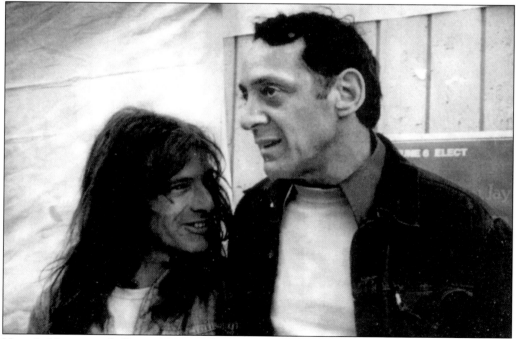

Here is Harvey with Dennis Peron, the Castro's neighborhood dope dealer, supporting the Marijuana Initiative. Dennis ran the Island Restaurant, where several Milk campaign functions were held. (Photo Dennis Peron.)

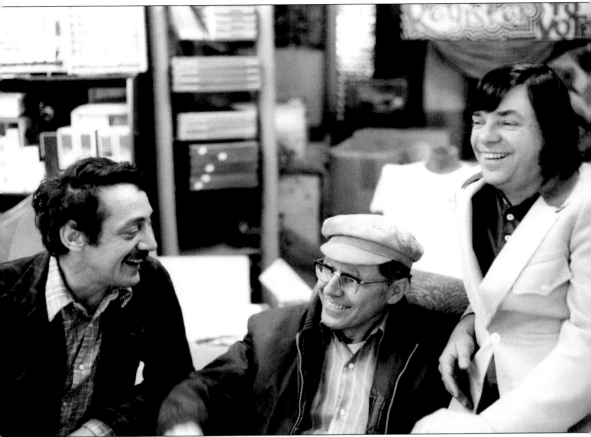

Harvey, left, is shown here chatting in the camera store with his campaign speechwriter Frank Robinson, the successful sci-fi author who wrote the book on which *The Towering Inferno* was based. On the right, visiting from New York, is his old friend Tom O'Horgan, who directed *Hair*, *Jesus Christ Superstar*, and *Lenny*. (Photo Harvey Milk Archives–Scott Smith Collection, San Francisco Public Library.)

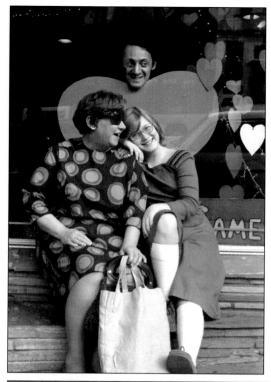

Young Medora Payne walked into the shop one day and insisted on helping Harvey in his state assembly campaign. Campaign manager John Ryckman called Medora's mother, who assured him there was no way to stop the little dynamo. Here's Harvey looking out the shop window at Medora and her mother on Valentine's Day. (Photo Daniel Nicoletta.)

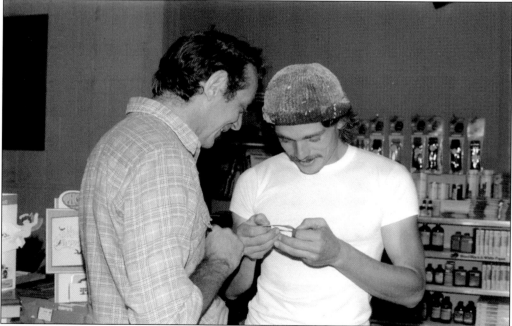

Harvey's protégé Dan Nicoletta wanted to include this shot of Harvey sharing a comic strip with Denton Smith. It illustrates the special, easy relationship Harvey had with all the young men in the neighborhood. (Photo Daniel Nicoletta.)

Attendance at the Castro Street Fair increased every year. In these first fairs there were no booths in the middle of the street—it was just two blocks of solid people. (Photo Crawford Barton, courtesy GLBT Historical Society.)

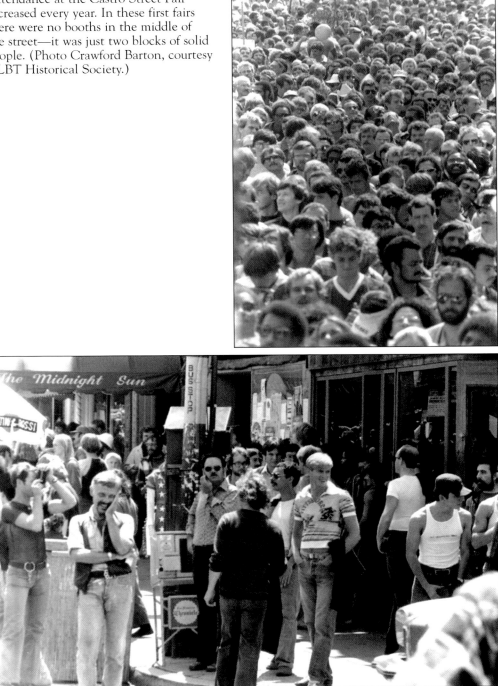

Sometimes there's a little break in the crowd. The Midnight Sun, which Todd Trexler used to decorate, later moved to Eighteenth Street, a block away, and became one of the first video bars. (Photo Rink Foto.)

This shot is from Lee Fowler's Clip Joint, a hair salon above what was then The Elephant Walk and is now Harvey's, on the corner of Castro and Eighteenth Streets. (Photo Janis Greenberg.)

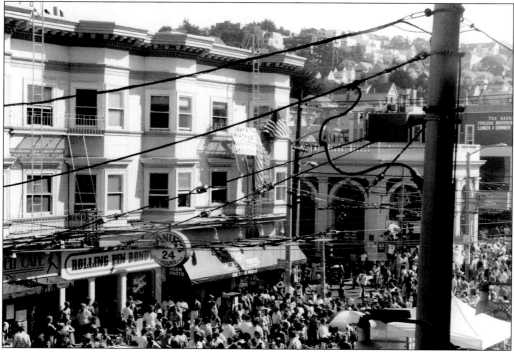

Another view of an early Castro Street Fair shows that the area was becoming more popular. (Photo Robert Meslinsky.)

Prince Jesus Christ Satan (later known as
Prince Arcadia) is a familiar street character.
(Photo Crawford Barton, courtesy GLBT
Historical Society.)

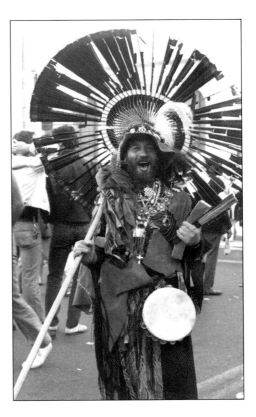

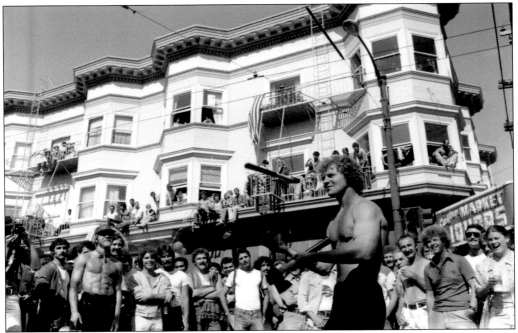

One popular street performer is juggler Ray Jason, shown here at the 1977 fair.

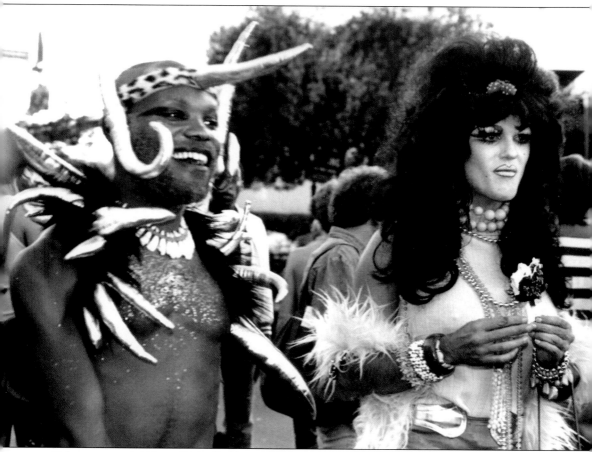

Sylvester protégé Gerry Kirby (left) attended the 1976 fair with another famous drag personality, Doris Fish, who later starred in the 1991 movie *Vegas in Space*. Doris said, "Once you put on makeup, you don't need any other drug." (Photo Daniel Nicoletta.)

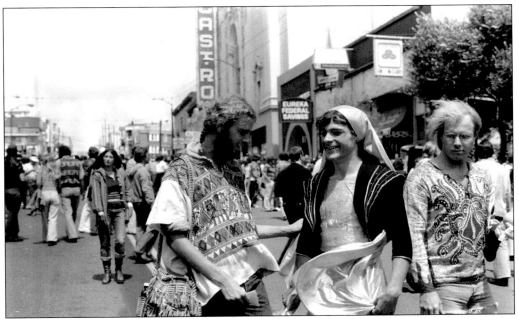

The gentleman in the center is Marc Huestis, one of the founders of the San Francisco International Lesbian and Gay Film Festival, which now shows 200 films to 80,000 attendees annually. Marc is also the impresario who stages many "camp" celebrity evenings at the Castro Theatre. (Photo Daniel Nicoletta.)

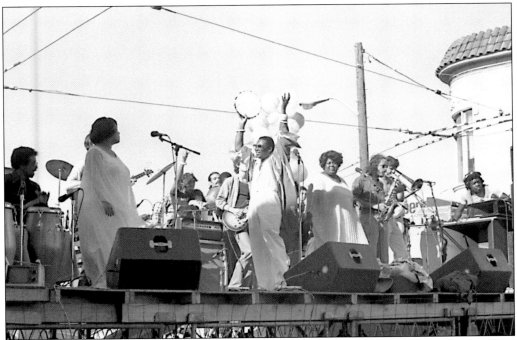

Former Cockette Sylvester, now an internationally acclaimed disco diva, sings his hit "You Make Me Feel Mighty Real" at the 1978 fair. (Photo Daniel Nicoletta.)

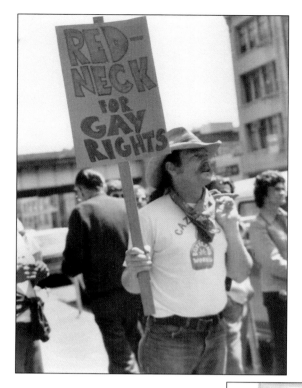

Of course, amidst all this fun there are people supporting special groups and causes. (Photo Janis Greenberg.)

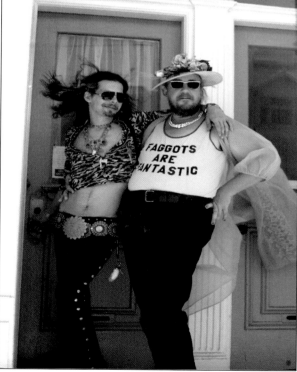

Our cover photographer, Dan Nicoletta, feels the spirit of the era is captured in this photo of Harmodius, left, and Hoti, right, setting out to attend the Castro Street Fair. (Photo Daniel Nicoletta.)

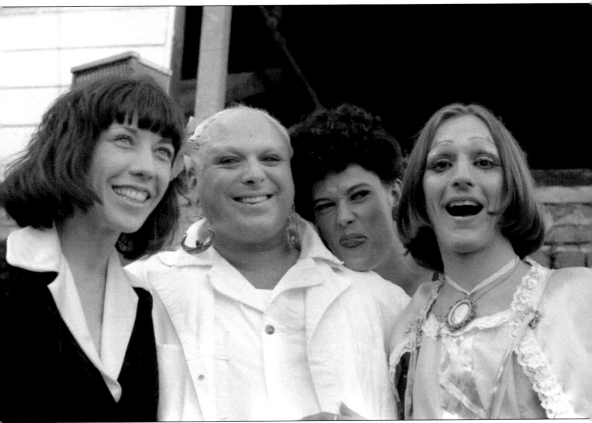

In June 1975 John Waters film star Divine held an autograph signing party at the Bakery Cafe on Castro Street. From left to right are Lily Tomlin, Divine, Sister Ed, and Pristine Condition. (Photo Daniel Nicoletta.)

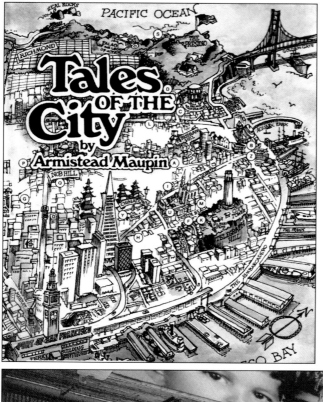

The spirit of the Castro is captured in Armistead Maupin's *Tales of the City*, which ran as a serial in the *San Francisco Chronicle* in 1976, before being published in book form in 1978. Though the book isn't set in the Castro, it captures the spirit of people of all persuasions living as close friends. In 1981 Armistead moved to Twenty-first and Noe in the Castro, where he lived until 1988. (Photo Harper & Row.)

In 1977 Mahmood and Ahmad Ghazi opened the indoor/outdoor Café Flore on the corner of Market and Noe. Their baby photos appear on the billboard above the café. The Flore became the perfect, friendly, low-key meeting place for a quarter century. In 2003 Mahmood and Ahmad sold to new owners who are continuing the friendly tradition. (Photo Mahmood Ghazi.)

Shown here is the Market Street entrance to the Café Flore. (Photo Mahmood Ghazi.)

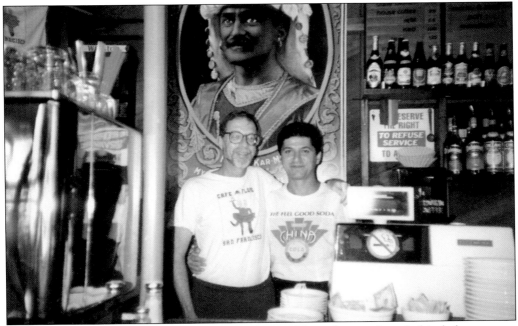

Your author moved into the Castro in the late 1970s and poses here behind the counter at the Café Flore with owner Mahmood. That's the notorious Kar-Mi in the poster in the background. Kar-Mi sees all, knows all. Kar-Mi is pals with Ash-Kar, your author's imaginary spirit guide. (Photo Strange de Jim.)

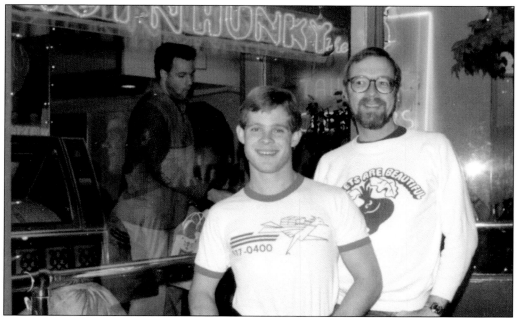

Your author and best friend Tom Boyer pose outside Hot 'N Hunky for the confusing photo "Which one's Hot? Which one's Hunky?" Herb Caen, lead columnist for the *San Francisco Chronicle*, printed hundreds of Strange musings ("Monogamous is what one partner in every relationship believes it to be." "My sexual preference is the Mormon Tabernacle Choir.") Your author is San Francisco's Town Fool. (Photo Robert Meslinsky.)

In the Castro, by accidentally doing something very simple yet very unusual, your author has made literally hundreds of wonderful friends. Here are a few of them posing for a publicity photo for my 1980 autobiography *The Strange Experience*. (Five-thousand copies were printed. Luckily, the plates were accidentally destroyed.) (Photo Stan Maletic.)

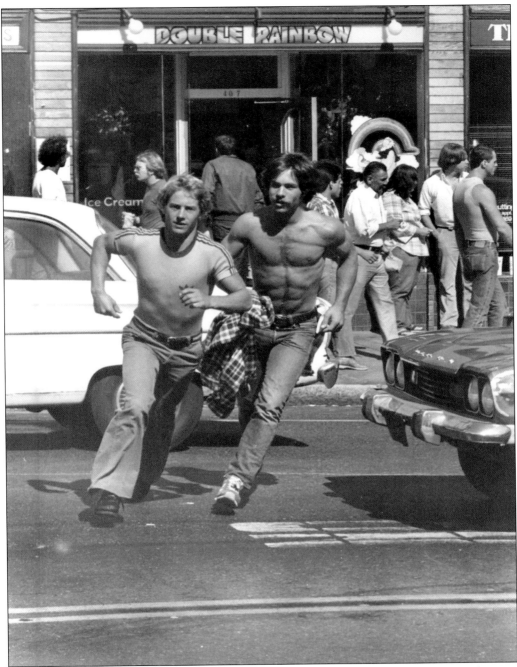

Although I don't know these two men, this photo sums up what the Castro was like for your author. I'd hear a joyful, "Strange!,"and here they'd come. Why was I attracting hundreds of friends way too good for me? It's taken me another 20 years to figure it out. (Photo Crawford Barton, courtesy GLBT Historical Society.)

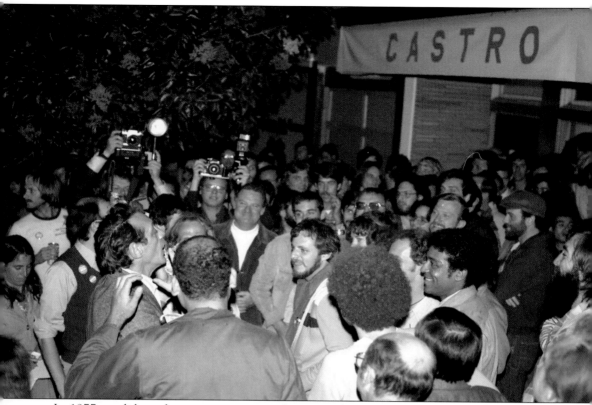

In 1977 candidates for supervisor ran in their own districts, rather than competing citywide. Harvey Milk swept the Castro and became the first openly gay person to win a major public office in California. At this victory party outside Castro Camera the man in the center in the white turtleneck is Allan Baird, the Teamster official in charge of the Coors boycott. He and his wife had lived in the neighborhood all their lives. He had gotten up his courage and approached Harvey about getting gay bars to boycott Coors and was impressed when Harvey asked in return only that gay people be given jobs as truck drivers. Harvey got Coors banned in gay bars throughout California. Allan kept his word and hired gay drivers. Harvey, amazingly, became the first openly gay candidate to be endorsed by the Teamsters, firefighters, and construction workers unions. (Photo Daniel Nicoletta.)

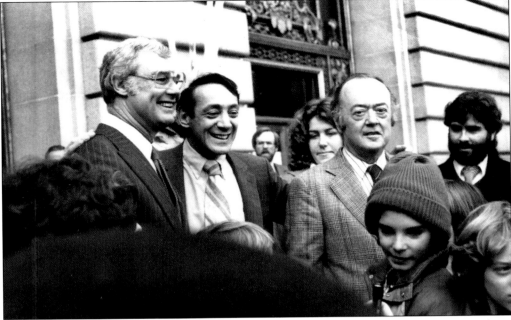

On the cover we see Daniel Nicoletta's shot of Harvey leading a parade from Castro Camera down Market Street to this January 9, 1978 swearing-in ceremony on the steps of the San Francisco City Hall. Shown here, from left to right, are Mayor George Moscone, Harvey Milk, Harvey's campaign manager Anne Kronenberg, and State Senator Milton Marks. (Photo Rink Foto.)

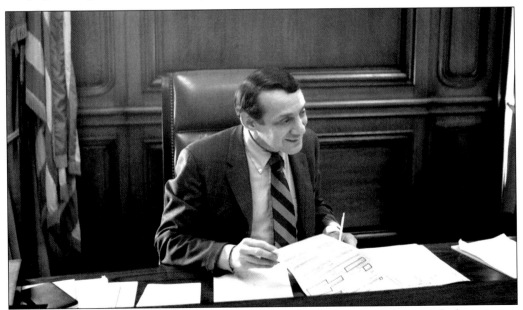

Harvey proved to be an effective supervisor, earning the respect of his colleagues for his concern for the working poor, the elderly, education, etc., as well as gay issues. He sponsored two measures in his brief time as supervisor. One was a Gay Civil Rights Bill, which Mayor Moscone signed with a lavender pen, and the other was a pooper-scooper law. (Photo Daniel Nicoletta.)

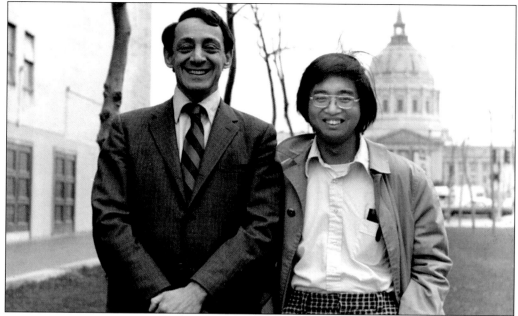

Supervisor Milk poses at city hall with Michael Wong, an activist for Chinese-American rights, who worked closely with Harvey for several years. Harvey believed in grass-roots action, with all the disenfranchised groups banding together. (Photo Daniel Nicoletta.)

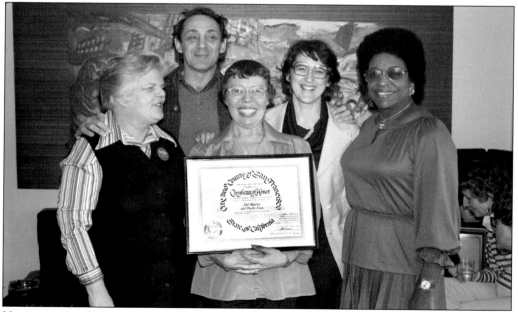

Harvey enjoys his ceremonial duties. Here Del Martin and Phylis Lyon, founders of The Daughters of Bilitis, the first national lesbian rights organization, are being presented with a Certificate of Honor from the City and County of San Francisco. From left to right, are Del Martin, Supervisor Harvey Milk, Phyllis Lyon, Supervisor Carol Ruth Silver, and Supervisor Ella Hill Hutch. (Photo Daniel Nicoletta.)

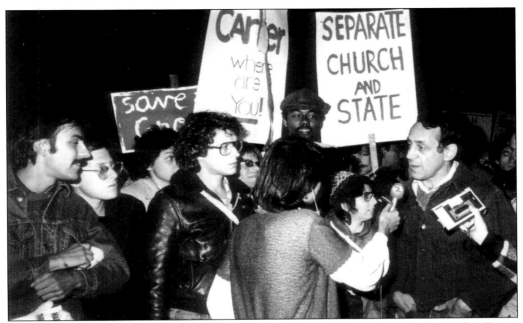

Cleve Jones (center, in glasses) and Harvey lead a five-mile protest march from the Castro through Pacific Heights to Union Square in 1977 when Miami repealed its gay rights ordinance. In 1978 California State Senator John Briggs began pushing Proposition 6, an initiative to ban gay people from teaching in public schools. As supervisor, Harvey toured the state debating Briggs. The initiative was defeated. (Photo Rink Foto.)

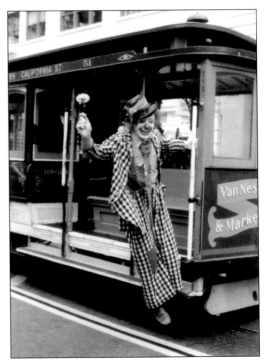

Harvey's sense of exuberance and fun is shown here when Ringling Brothers made him a clown for a day. He jumped onto cable cars, telling tourists, "I'm a Supervisor! Can you believe it?" (Photo Daniel Nicoletta.)

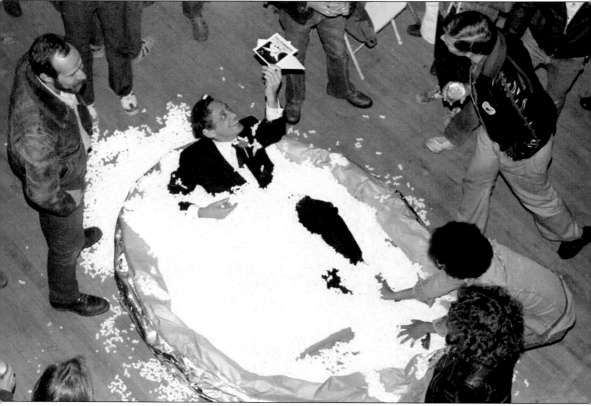

Harvey also had a blast in 1978 on his last birthday. He and his friends had a tradition of throwing pies in each others' faces, and here he has just been pushed into a giant pie made of styrofoam peanuts. Only Harvey suspected what was going to happen next. He tape recorded three copies of a will to be read in the event he was assassinated. (Photo Daniel Nicoletta.)

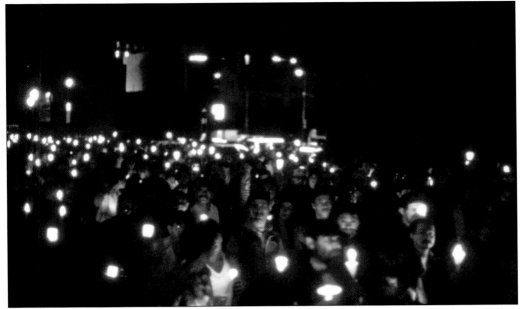

On November 27, 1978, at San Francisco City Hall, disgruntled former Supervisor Dan White shot and killed Mayor George Moscone and Supervisor Harvey Milk. Here, a spontaneous solemn candlelight march of 40,000 people makes its way from the Castro to the city hall, where Joan Baez sang "Swing Low, Sweet Chariot." (Photo Daniel Nicoletta.)

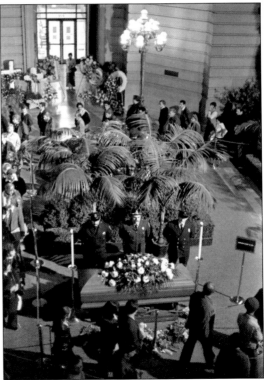

Harvey and George Moscone lie in state in the rotunda at city hall. Over 10,000 mourners filed past the caskets. Moscone's funeral was at St. Mary's Cathedral. Services for Harvey were held first at Temple Emmanue-El and then at a packed Opera House, where Governor Jerry Brown, the California Chief Justice, Acting Mayor Dianne Feinstein, Divine, Tom O'Horgan, and a White House representative were among the mourners. (Photo Daniel Nicoletta.)

Pictured here are Harvey's ashes, ready for burial at sea. They are wrapped in *Doonesbury* and *Peanuts* comic strips because Harvey loved the comics. (Photo Dan Nicoletta.)

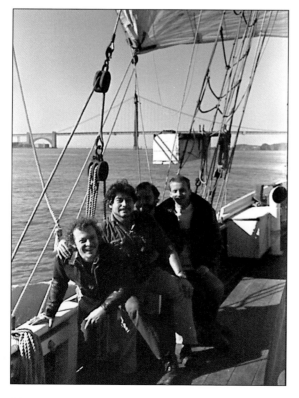

These are the "Milk Widows," Harvey's former lovers, on December 2, 1978, the day Harvey's ashes were scattered at sea. Pictured here, from left to right, are Scott Smith, Galen McKinley, Joe Campbell, and Billy Wiegardt. (Photo Daniel Nicoletta.)

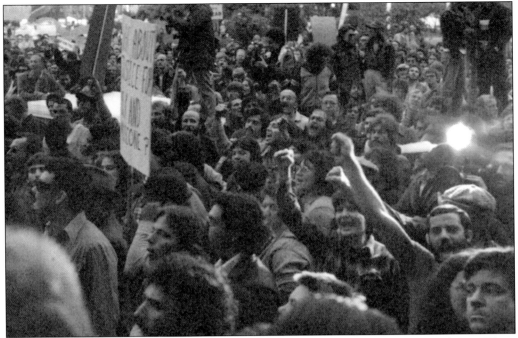

On May 21, 1979, after inept prosecution and brilliant defense, the jury convicted Dan White of manslaughter only, rather than murder. Angry crowds formed in the Castro and marched to city hall. (Photo Robert Meslinsky.)

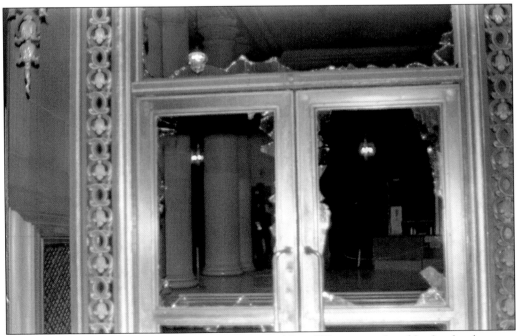

Crowds, angered by the manslaughter conviction of Dan White, rioted and broke the doors on city hall, shown here. (Photo Daniel Nicoletta.)

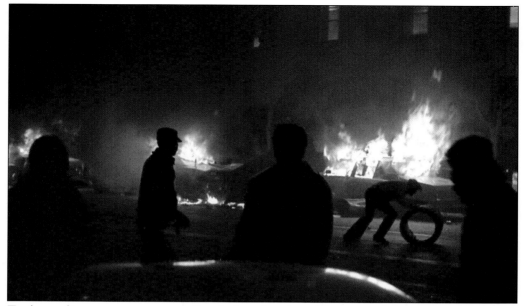

Twelve police cars were set on fire during the riots. The scene didn't settle down until midnight when a line of police cars filled with angry cops drove to the Castro, where everyone in sight was beaten. The police stormed the Elephant Walk, smashing fixtures and heads. A hundred rioters and police were hospitalized. (Photo Daniel Nicoletta.)

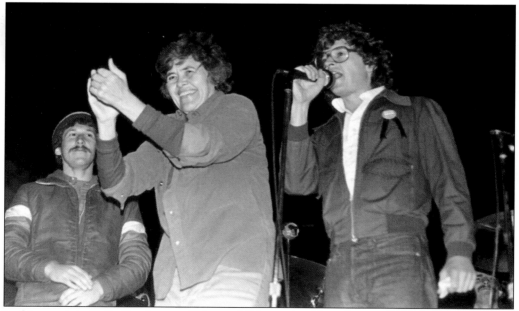

Lesbian activist Sally Gearhart and Harvey Milk protégé Cleve Jones spoke the very next night at a big Harvey Milk Memorial Birthday Party, which had already been scheduled for Castro Street. The police kept out of sight, with a command post on the second floor of Cliff's, and the evening passed peacefully. In an odd way the gay riot and the police riot seemed to cancel each other out, and relations returned more or less to normal. (Photo Daniel Nicoletta.)

Photographer Daniel Nicoletta, shown above at age 20, one of the people closest to Harvey, shares his feelings: "My life as a photo-documentarian of the journey of the gay, lesbian, bisexual and transgender communities of San Francisco really began in 1975, at age 20, when Harvey Milk and his lover Scott Smith asked me to work in their Camera Store at 575 Castro. Castro Street was an exhilarating epicenter of social, political, economic, and artistic synergy then, and my long romance with San Francisco began there. Harvey and Scott were like gay parents to me, and the funhouse environment that was Castro Camera gave way to my initiation into political activism as well as freelance photography. Harvey and Scott took a genuine interest in my photography and love of theatre, and with wry amusement they coached me in the nuances of gay life. They enjoyed hearing about my sexual exploits. They took delight in my naiveté, and were determined to deconstruct my last traces of self-doubt (I had only recently come out). They succeeded." (Photo Harvey Milk Archives–Scott Smith Collection, San Francisco Public Library.)

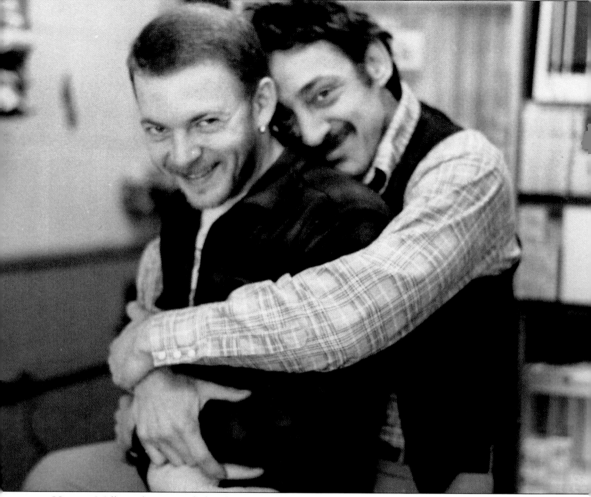

Harvey Milk is shown with his lover Scott Smith. Daniel Nicoletta continues: "It's important to remember that Harvey and Scott were artists. Both men were photographers, and both had a keen sense of the artistic and the theatrical, which informed their politics and their lives. A deep and lovely metaphysical imprint remains on my soul from their mentorship. Now when I think of Harvey and Scott I know that a sense of delight in history is one of the greatest tools they taught me. I still hear Harvey ranting, 'If it isn't fun, it isn't worth it,' which was his antidote to the intensity he was experiencing as his political career accelerated. It's often debated to what degree Harvey and Scott were spiritual men. They were very pragmatic, but their love of creativity and their devotion to paving the way for a better future for queers and all disenfranchised people provide the clues necessary to answer that question." (Photo Marc Cohen.)

Three

1980s

At the start of the 1980s Most Holy Redeemer was about to close. A lack of children had already forced closure of both the Most Holy Redeemer School and the convent where the teachers lived. None of the three priests during the 1970s had wanted anything to do with the gay men surrounding the church. In 1982 Father Tony McGuire became pastor and changed all that. (Photo Most Holy Redeemer.)

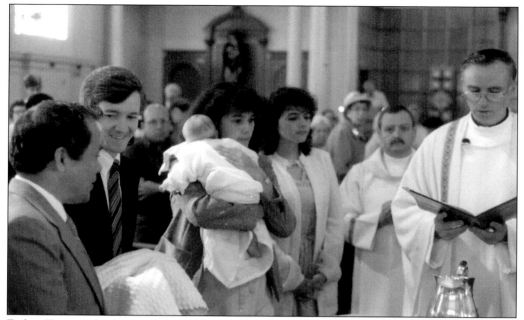

Father Tony performs a baptism. Although he was very wary of the idea, rather than letting his church close, he decided to conduct an outreach program to the gay Catholics in the parish. Two gay parishioners gathered names and sent out invitations, and 65 gay men showed up for a potluck. Father Tony decided to treat homosexuality as similar to couples deciding to use contraception. It was a matter of personal conscience, and the person could still be a good Catholic. (Photo Most Holy Redeemer.)

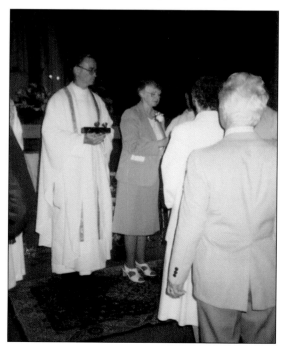

Father Tony also caused a stir among the older parishioners by choosing a woman, Sister Cleta Herold, as associate pastor. Father Tony and Sister Cleta found that there was a natural affinity between "the gays and the grays," the older women who had outlived their husbands and whose children had moved away, and the young gay men whose parents were far away. (Photo Most Holy Redeemer.)

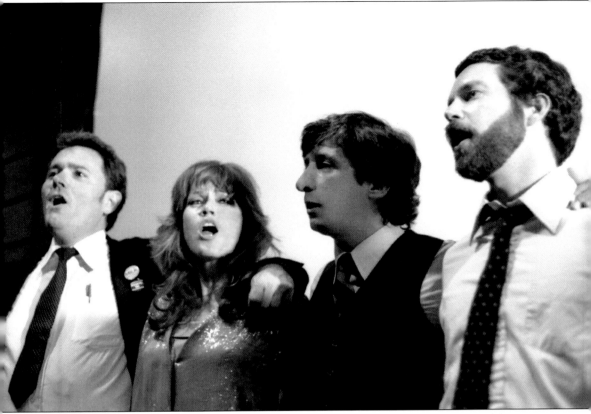

Shown here at the Harvey Milk Gay Democratic Club Annual Dinner May 22, 1980 celebrating Harvey Milk's natal birthday, from left to right, are Supervisor Harry Britt; Jane Fonda; Tom Haydn, the keynote speaker; and Bill Krause, Congressman Phil Burton's administrative aide. They led the attendees in singing happy birthday to the late Harvey. Teamster leader Allan Baird took Ms. Fonda to task for drinking a Coors in her latest movie, heedless of the boycott. She apologized. (Photo Daniel Nicoletta.)

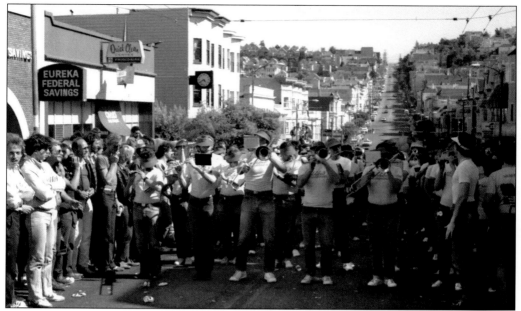

The Harvey Milk legend had already started. Here the Gay Men's Marching Band performs at a Harvey birthday celebration on Castro Street in 1980. (Photo Daniel Nicoletta.)

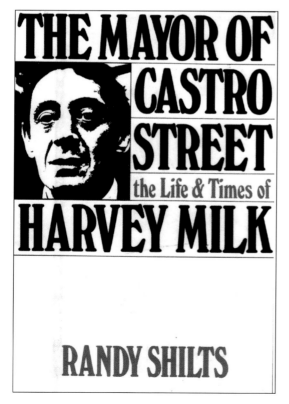

In 1982 gay journalist Randy Shilts published *The Mayor of Castro Street*, a book about Harvey Milk that was later made into an Oscar-winning documentary, *The Times of Harvey Milk*. (Photo St. Martin's Press.)

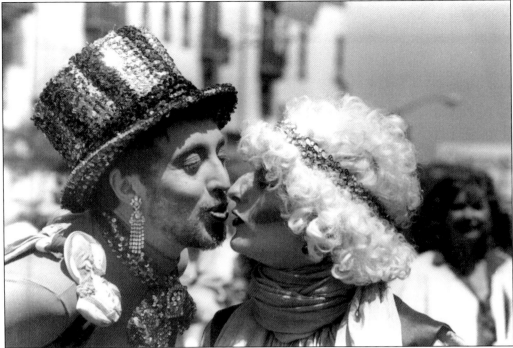

At the 1980 Castro Street Fair we find Gilbert Baker, who created the Rainbow Flag for the 1978 Gay Pride Parade, kissing someone who looks a lot like actor Richard Chamberlain. What do you think? (Photo Robert Pruzan, courtesy GLBT Historical Society.)

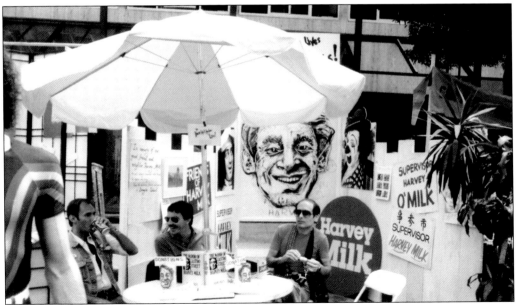

At a Harvey Milk Archives booth at the 1982 Castro Street Fair, from left to right, David Pasko, Tommy Buxton, and Bernard Spunberg seek community help in preserving the legend. (Photo Daniel Nicoletta.)

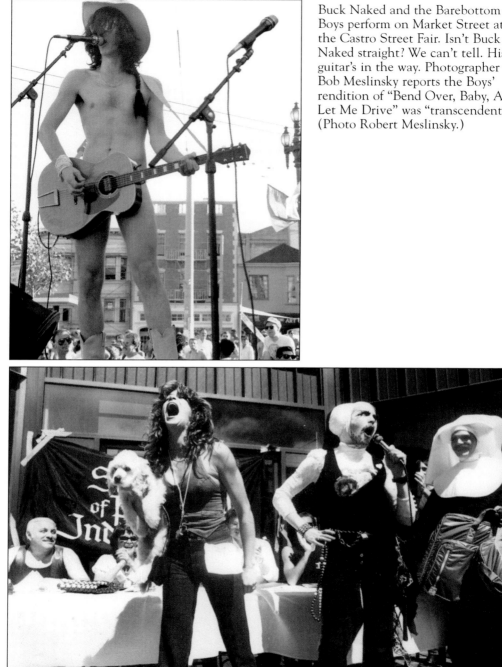

Buck Naked and the Barebottom Boys perform on Market Street at the Castro Street Fair. Isn't Buck Naked straight? We can't tell. His guitar's in the way. Photographer Bob Meslinsky reports the Boys' rendition of "Bend Over, Baby, And Let Me Drive" was "transcendent." (Photo Robert Meslinsky.)

Here are the howling winners of the first Castro Street Dog Show, along with a howling Sister Boom-Boom, most famous of the Sisters of Perpetual Indulgence. Sister Boom-Boom later got 23,000 votes in a run for supervisor, listing her occupation as "Nun of the Above." The man on the far left is Mister Marcus, leather columnist for the *Bay Area Reporter*. (Photo Robert Pruzan, courtesy GLBT Historical Society.)

Late photographer Robert Pruzan noted on his print, "Dog Show Entrant 1982 contest. The dog looked well dressed too." Don't you just want to know what this lady and gentleman is thinking? (Photo Robert Pruzan, courtesy GLBT Historical Society.)

Here's a Sister of Perpetual Indulgence who has set up her own pew on Hibernia Beach, the sidewalk in front of Hibernia Bank at Eighteenth and Castro. The Sisters are a religious/political/street theater organization, formed on Easter Sunday, 1979. They do charity work, while causing mayhem wherever they go. (Photo Robert Pruzan, courtesy GLBT Historical Society.)

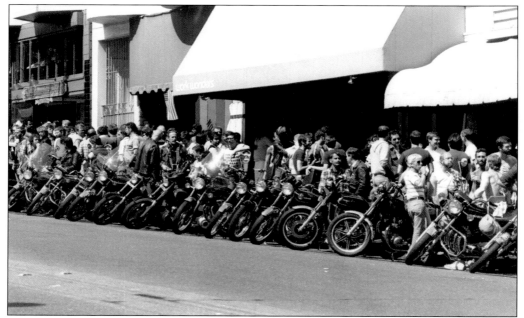

Another group of worshipers are, of course, bikers. Here they are outside the No Name Bar, just a couple of doors down from All American Boy. The Castro always has a few leather bars. (Photo Crawford Barton, courtesy GLBT Historical Society.)

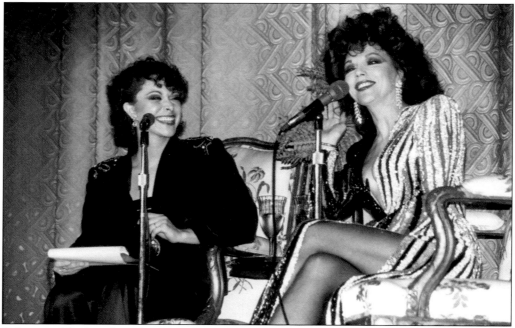

Other neighborhood residents worship celebrities. Here at the Castro Theater are, on the left, Lia Belli, wife of famed attorney Melvin Belli, and Joan Collins, bantering with each other and the audience. (Photo Robert Pruzan, courtesy GLBT Historical Society.)

Ginger Rogers also appeared at the Castro Theatre. (Photo Robert Pruzan, courtesy GLBT Historical Society.)

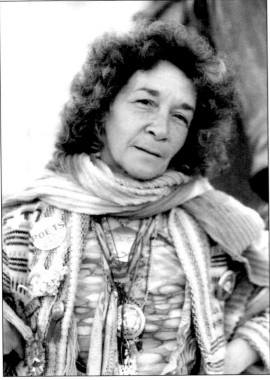

Cosmic Lady, street poet and metaphysician, lent her wisdom to anyone who wanted it. (Photo Daniel Nicoletta.)

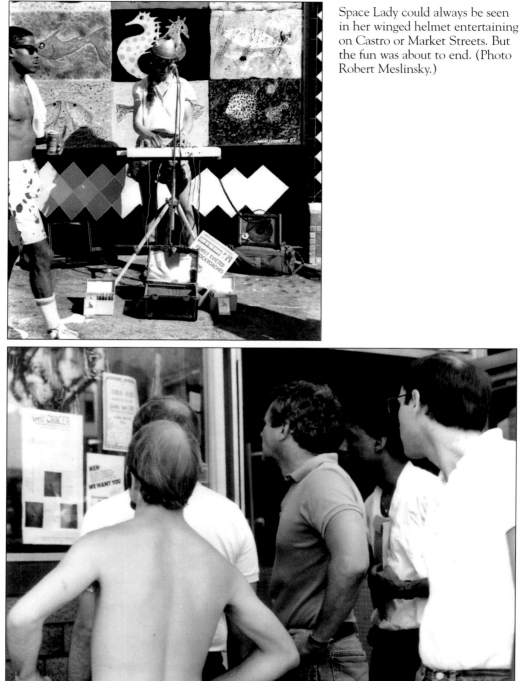

Space Lady could always be seen in her winged helmet entertaining on Castro or Market Streets. But the fun was about to end. (Photo Robert Meslinsky.)

Gay men started dying of a mysterious disease, often beginning with lesions known as Kaposi's sarcoma. In December 1981, Bobbi Campbell, a young man suffering from the disease, posted photos of his lesions in the window of Star Pharmacy (now Walgreens) on the corner of Castro and Eighteenth to help other men evaluate their own blemishes. (Photo Rink Foto.)

Bobbi Campbell, also known as the AIDS Poster Boy, appeared at a rally with his lover Bobby Hilliard in 1983. Bobbi did his best to publicize information about the disease and get funding for research. (Photo Rink Foto.)

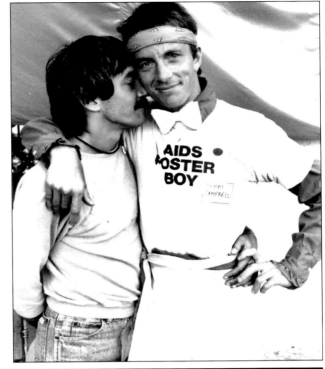

In this 1984 photo is Bobbi Campbell's memorial service, held on a closed-off Castro Street. His lover, Bobby Hilliard, is pictured between Bobbi's parents. (Photo Rink Foto.)

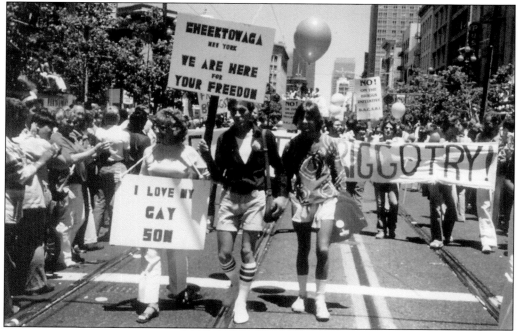

The effect of AIDS can be seen in Bob Meslinsky's experience. Here he is in the center of the 1978 Gay Pride Parade. His mother, Rose Marie, is on the left, and his boyfriend George Orr is on the right. (Harvey Milk had asked people to carry a sign telling where they were from so people could see gays came from everywhere.) Bob lost his boyfriend to AIDS in the early 1980s. (Photo Robert Meslinsky.)

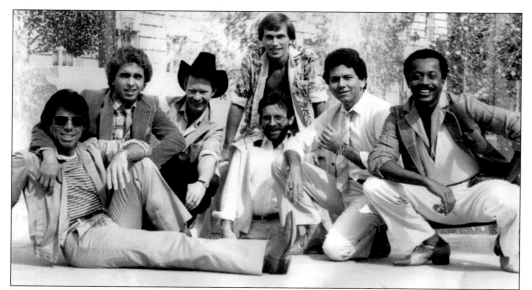

Bob Meslinsky is in the center rear of this photo of the crew at David Andrews Menswear on Eighteenth Street, where he worked. Four of these seven people died of AIDS. Your author's own experience is similar. In 1980 I published *The Strange Experience*, which had photos of my hundred closest friends. By 1990 half of them had died of AIDS. (Photo Tory Jeffries.)

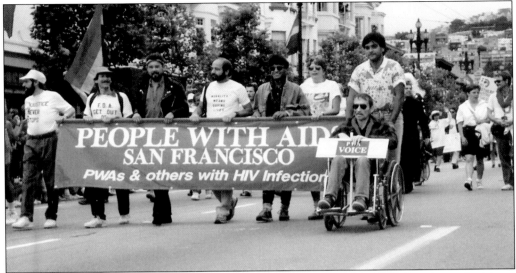

The Castro community response to AIDS became a model for the world. People pitched in to feed and take care of the sick and to raise money for a cure. AIDS groups of various sorts filled the Gay Pride Parade. (Photo Mahmood Ghazi.)

There was some good news amid the tragedy. In 1985 Director Rob Epstein (center) won an Oscar for Best Documentary for *The Times of Harvey Milk*. He later won another Oscar for *Common Threads*, the story of the AIDS Quilt. With Rob at the Café Flore are his partner Jeffrey Friedman (left) and David Weissman, who later directed *The Cockettes* movie. (Photo Daniel Nicoletta.)

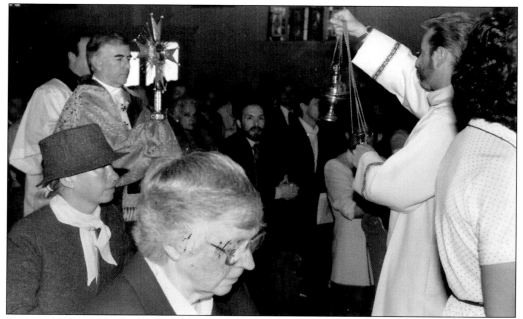

For years Most Holy Redeemer had a 40-Hours Observance in which the names of those who died were read and prayers were offered. Here Archbishop Quinn, on the left, takes part in the services. He also regularly visited the patients at Coming Home Hospice. His successor, Archbishop Levada, did not follow suit. (Photo Father Donal Godfrey.)

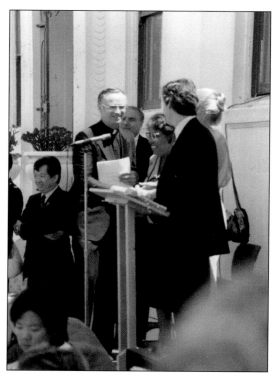

In the 1986 40-Hours Observance Most Holy Redeemer turned its empty convent into the Coming Home Hospice for AIDS patients near death. This photo shows the dedication ceremony. (Photo Most Holy Redeemer.)

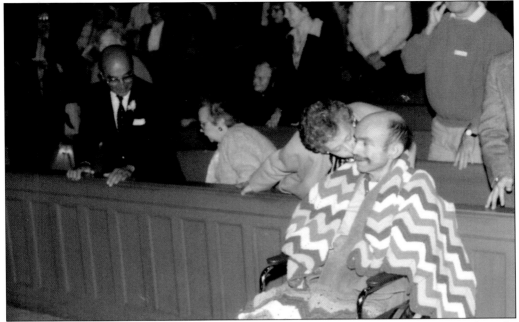

In 1987, in the sanctuary of Most Holy Redeemer, a mother kisses her son, who has been brought over from Coming Home Hospice to take part in his parents' 50th wedding anniversary. His father stands with his hands on the rail. (Photo Most Holy Redeemer.)

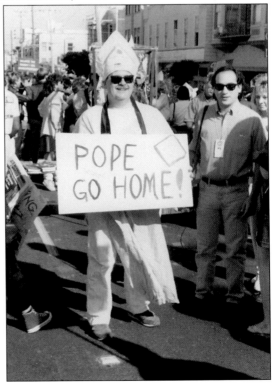

Though Most Holy Redeemer ministered to gay parishioners, the Catholic Church as a whole remained decidedly anti-gay. This man is protesting the Pope's visit to Mission Dolores, just outside the Castro, in 1986. (Photo Robert Meslinsky.)

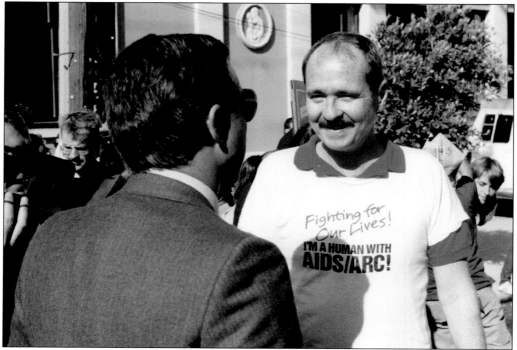

Leonard Matlovich protests the Pope's visit in 1986. He made the cover of *Time* when he was discharged from the Air Force for coming out. He died of AIDS in 1988. (Photo Robert Meslinsky.)

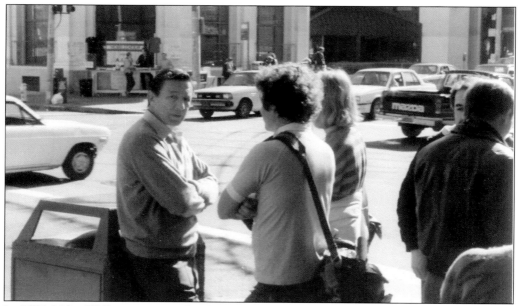

In 1986 Mike Wallace came to the Castro to report on the AIDS crisis. Five years into the epidemic, President Reagan had not mentioned AIDS. The media avoided the subject for fear of offending readers/viewers and/or advertisers. (Photo Robert Meslinsky.)

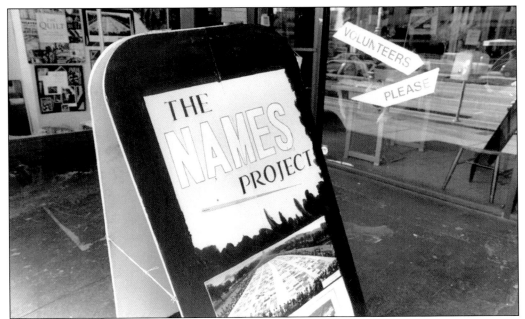

Harvey Milk's protégé Cleve Jones had a vision and started the NAMES Project to let friends and family remember and memorialize their loved ones in quilt panels. The quilt has had an incredibly powerful effect. By 1997 it had grown to 44,400 panels, covering the equivalent of 16 football fields. Until it moved to Atlanta recently the project's headquarters was on Market Street near Castro. (Photo Rick Gerharter.)

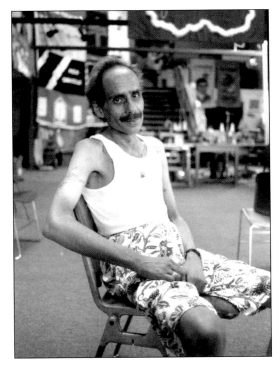

Shown here is early New York AIDS activist and Dan Nicoletta's dear friend, Michael Angarola, a man with AIDS, in the NAMES Project headquarters. Michael died soon after. (Photo Daniel Nicoletta.)

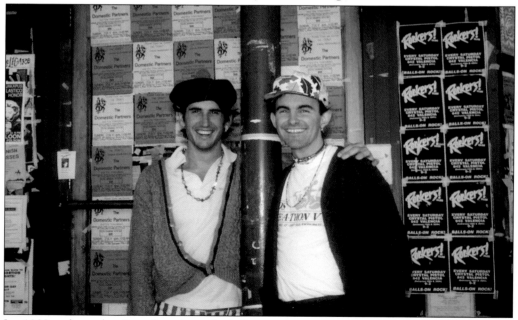

Photographer Janis Greenberg was moved when she saw this panel at a NAMES Project exhibition. It reads, "I have decorated this banner to honor my brother. Our parents did not want his name used publicly. The omission of his name represents the fear of oppression that AIDS victims and their families feel." (Photo Janis Greenberg.)

In 1989, when the San Francisco Archdiocese gave money to repeal domestic partner benefits for gay people, former seminarians James Kennedy, on the left, and his lover Derrick Tynan-Connolly handed out a protest letter to all the parishioners at Most Holy Redeemer and several other Catholic churches. (Photo James Kennedy and Derrick Tynan-Connolly.)

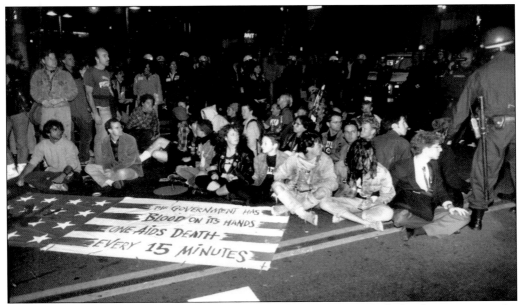

A group called ACT UP got very frustrated at the government's lack of response to the AIDS crisis and held many angry demonstrations, doing things like disrupting the morning commute on the Golden Gate Bridge. On October 6, 1989, after ACTing-UP in the San Francisco Civic Center, they marched to the Castro, where they sat down in the middle of the street. (Photo Rick Gerharter.)

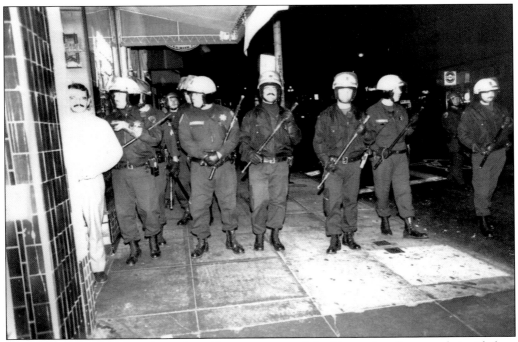

The frustrated police went berserk and began a sweep of the Castro, bottling people inside bars and restaurants and clubbing people at random. (Photo Rick Gerharter.)

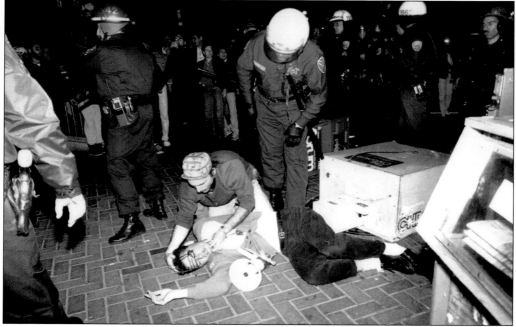

Call this man Random. (Photo Rick Gerharter.)

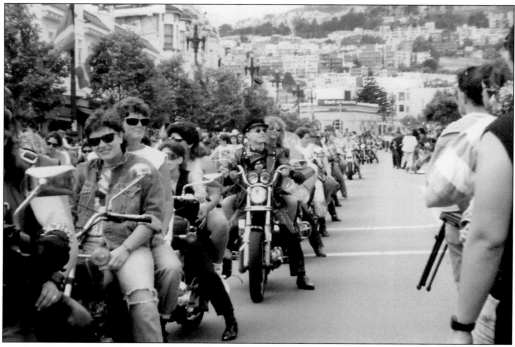

Still, life went on. Here are the Dykes on Bikes starting off the 1989 Gay Pride Parade. (Photo Mahmood Ghazi.)

Four

1990s

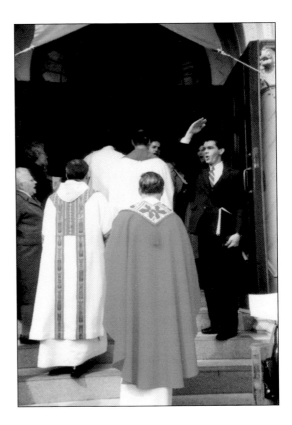

In 1990 Most Holy Redeemer celebrated beloved Father Tony McGuire's silver anniversary. Music Director John Oddo leads the singers. By then, Most Holy Redeemer Church was about 80 percent gay, making it the world's gayest Catholic Church. (Photo Most Holy Redeemer.)

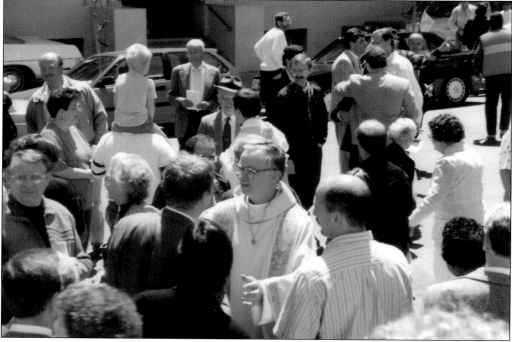

Then Most Holy Redeemer bids farewell to Father Tony, who took a dying church and turned it into a vital one. (Photo Most Holy Redeemer.)

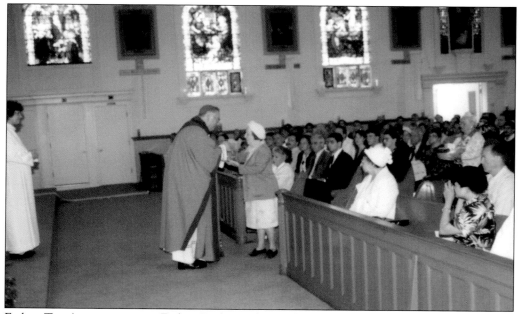

Father Tony's successor was Father Zachary Shore, shown here at his installation ceremony. He continued the policy of gay inclusiveness, going even further than Father Tony by not only baptizing babies of gay couples, but commemorating gay anniversaries along with straight ones from the pulpit. (Photo Most Holy Redeemer.)

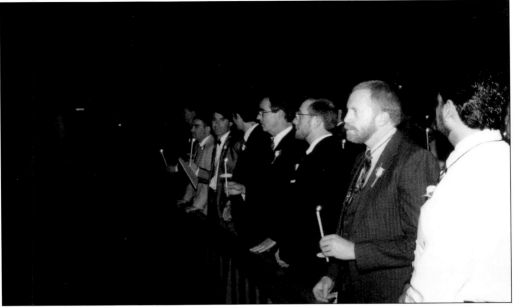

Most Holy Redeemer gained as a parishioner Jack Fertig (second from right with candle in his left hand). Jack was formerly Sister Boom-Boom, the most famous of the Sisters of Perpetual Indulgence. (Photo Most Holy Redeemer.)

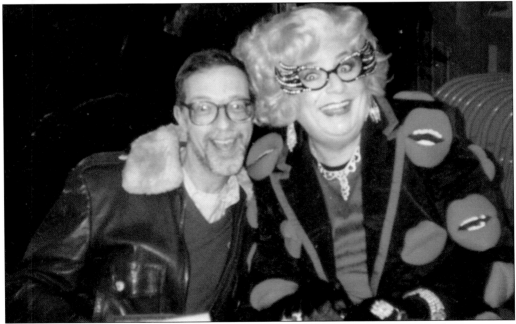

Dame Edna Everage is shown here at A Different Light Bookstore on Castro Street to sign her frank autobiography *My Gorgeous Life*. The author has loved her since her appearance on the old *Tonight Show* when she said her husband was back in Moonee Ponds, Australia, in an iron prostate, and advised Joan Rivers, George Hamilton, and Joan Collins never to try plastic surgery. (Photo Strange de Jim.)

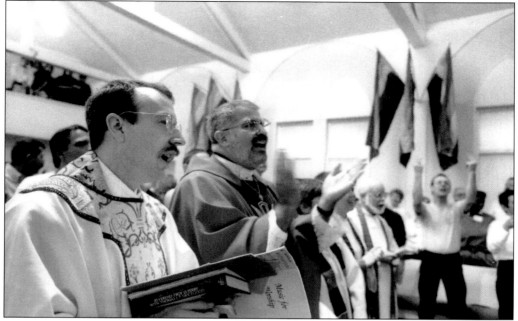

Reverend Jim Mitulski, shown here to the left, the head of the non-denominational gay Metropolitan Community Church on Eureka Street, is singing with Reverand Troy Perry, who founded MCC in Los Angeles in 1968. The MCC performs gay weddings and lets many groups use its facilities. (Photo Rick Gerharter.)

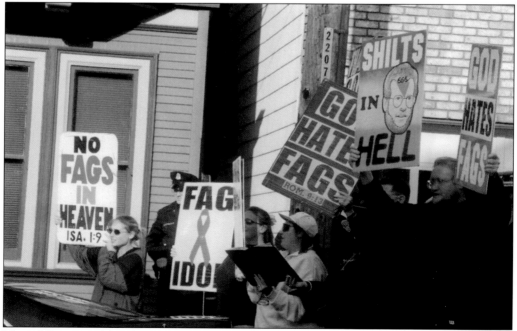

Here followers of gay-hating Reverand Jim Phelps show Christian love at Metropolitan Community Church. (Photo Rick Gerharter.)

In Collingwood Park in May 1990, Jillian Alexander participated in the annual Douglass School Carnival with her two moms. It must be her biological dad who has the big ears. Two-mom and two-dad families are fairly common in the neighborhood. (Photo Rick Gerharter.)

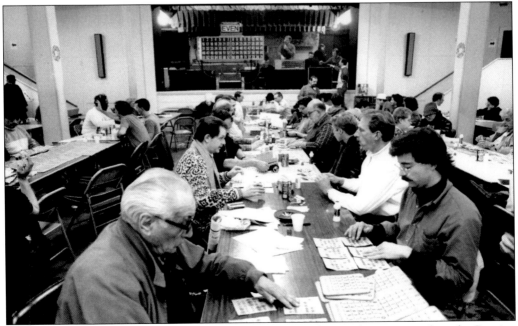

Shown here is a 1990 bingo game in the Most Holy Redeemer basement to benefit Coming Home Hospice. (Photo Rick Gerharter.)

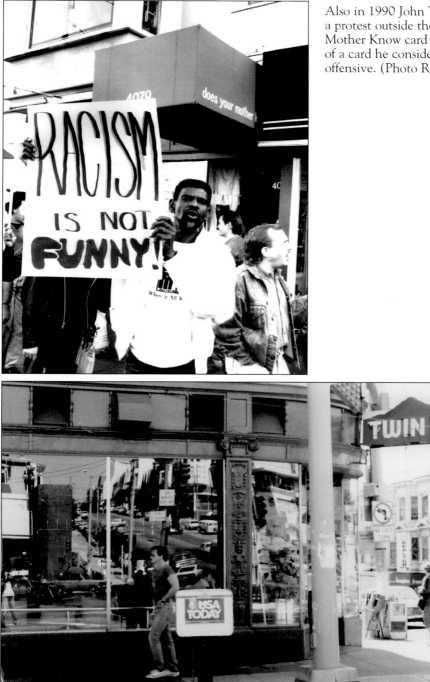

Also in 1990 John Teamer led a protest outside the Does Your Mother Know card shop because of a card he considered racially offensive. (Photo Rink Foto.)

Shown here is the Twin Peaks Bar, on the corner of Castro and Market. It has been a bar since 1939, and in 1973 became the first gay bar in San Francisco, and possibly the world, with big plate-glass windows so customers could see passersby and vice versa. Though it is a gay male bar, it was owned by lesbians from 1973 until early 2003. (Photo Janis Greenberg.)

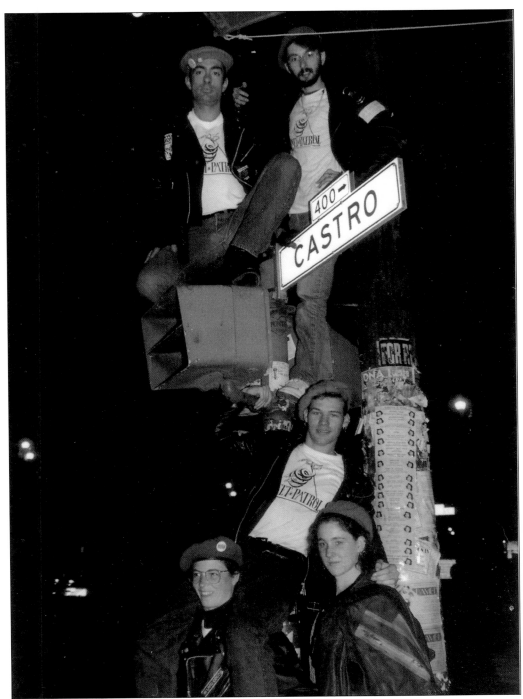

This 1991 shot is of The Street Patrol, one of several self-defense groups that have operated in the Castro. The Butterfly Brigade once persuaded everyone to buy whistles, and if a group of guys in a car yelled, "Hey, faggot!" they'd soon be surrounded by scores of angry men blowing whistles and trying to figure what part of them or their car to dismember. (Photo Rick Gerharter.)

AIDS continues. Here is James Harning in healthier days. When he got sick, he locked himself away and wouldn't see anyone. His friend Marcus Mitchinson dragged him to my place for a massage. (I'd volunteered to massage terminal patients, but seeing a close friend covered with lesions was heartwrenching.) (Photo Robert Meslinsky.)

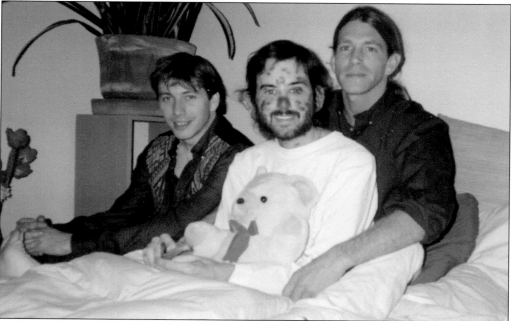

Shown here is James Harning, in the middle, with Marcus Mitchinson on the left and Stephen Pullis on the right. At the end, another friend and the author carried James to the car for his final ride to the hospital. (Photo Stephen Pullis.)

Farewell, friend. (Photo Sue Harning.)

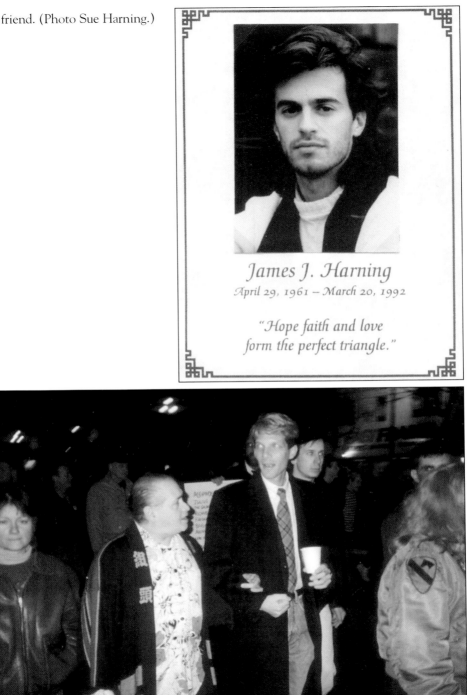

James J. Harning
April 29, 1961 – March 20, 1992

"Hope faith and love
form the perfect triangle."

In a Harvey Milk candlelight march on Market Street young Keith Meinhold walks with Jose Sarria. Keith was discharged from the Navy for being openly gay. He sued, won his case, and was reinstated. Jose is a legendary gay rights figure from the 1950s. (Photo Robert Meslinsky.)

Here is another legend, drag genius Justin Bond, at the 1992 Castro Street Fair. Justin is Kiki to Kenny Mellman's Herb in the duo Kiki and Herb, still wowing them in New York. (Photo Daniel Nicoletta.)

Miss America 1993 Leanza Cornett visited the NAMES Project on January 25, 1993. She is holding up a sweatshirt with the main ACT-UP slogan, "Silence=Death." (Photo Rick Gerharter.)

On January 22, 1993 Lily Tomlin hosted a benefit for *The Celluloid Closet* at the Castro Theatre. Shown here, from left to right, are Marga Gomez, Lypsinka, Harvey Fierstein, and Lily Tomlin. (Photo Rick Gerharter.)

This is the famous (Marijuana) Brownie Mary Rathburn at a medical marijuana dispensary in the Castro in 1994. (Photo Rick Gerharter.)

Actor James Kennedy portrayed Harvey Milk in a one-man show, *You Gotta Give 'Em Hope: Harvey Milk in His Own Words*. It was his master's degree project at the American Conservatory Theater in 1993, and he presented it again at Josie's Juice Joint in the Castro in 1995. Here he depicts Harvey's Navy career before he moved to San Francisco. (Photo Derrick Tynan-Connolly.)

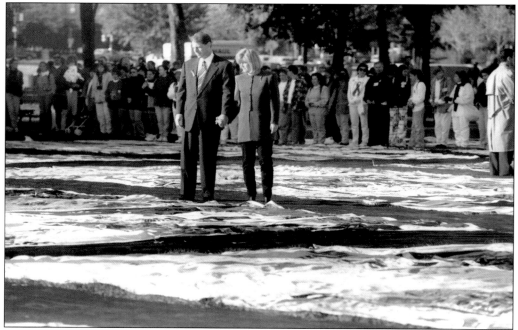

On October 11, 1996 Vice President Al Gore and his wife, Tipper, viewed the AIDS Quilt on the Mall in Washington, D.C. President Bill Clinton and First Lady Hillary Clinton also visited the quilt. (Photo Rick Gerharter.)

100

This October 1996 view of the entire Quilt captured the largest showing to date. (Photo Rick Gerharter.)

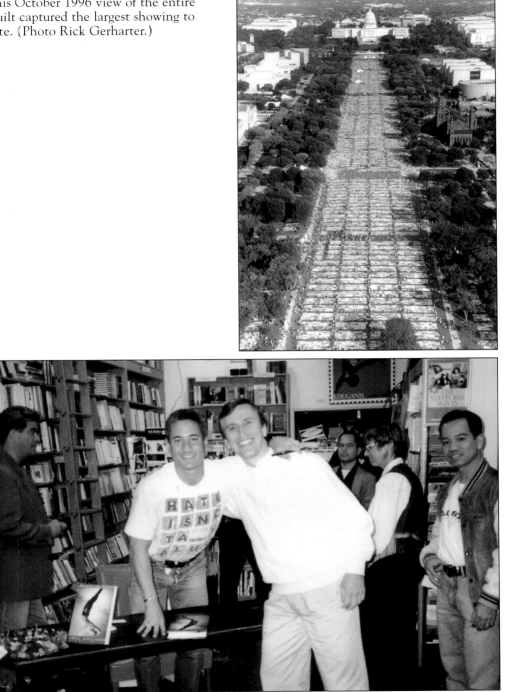

Gay four-time Olympic gold medal diver Greg Louganis came to A Different Light Bookstore in 1996 to sign his autobiography *Breaking the Surface*. Here he has his arm around our friend Bob Meslinsky. (Photo Robert Meslinsky.)

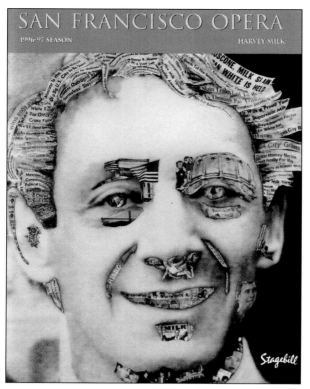

In its 1996–1997 season The San Francisco Opera presented the opera *Harvey Milk*, which has been performed in Houston, New York, and Dortmund, Germany. (Photo collage Brett Kaufmann.)

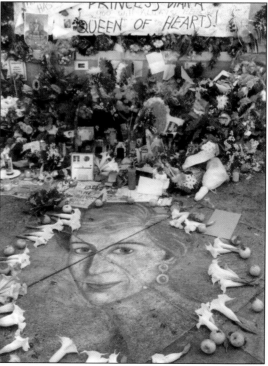

In 1997 Princess Diana, another gay icon, died a tragic death. She was memorialized here with a spontaneous tribute on the corner of Eighteenth and Castro. (Photo Robert Meslinsky.)

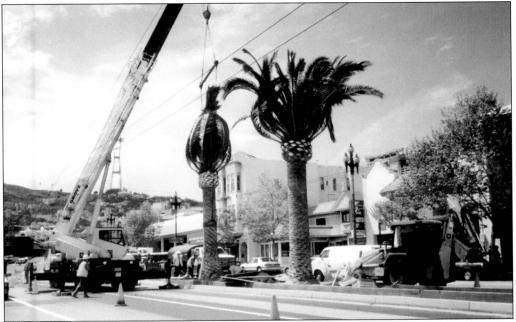

Full-grown palm trees suddenly appeared in the middle of Market Street. Note in the center, under the crane, lies the Sutro Tower, the television tower atop Twin Peaks that has dominated the skyline since 1973. (Photo Robert Meslinsky.)

At the 1998 Castro Street Fair couples square dance on Eighteenth Street. In the beginning the fair was two blocks of Castro between Market and Nineteenth. Now it also extends down Market to Noe, down Seventeenth to Hartford, west on Eighteenth to Collingwood, and east on Eighteenth to Noe. (Photo Robert Meslinsky.)

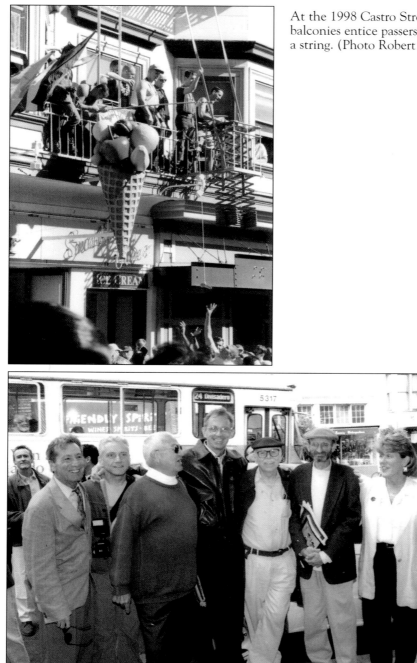

At the 1998 Castro Street Fair men on balconies entice passersby with a dildo on a string. (Photo Robert Meslinsky.)

On July 1, 1998 a mural of Harvey Milk, on the wall above his old camera shop, was dedicated. Attending, from left to right, are Supervisor Tom Ammiano, photographer Daniel Nicoletta, campaign manager for Harvey's Assembly race John Ryckman, Harvey's aide Dick Pabich, Harvey's speechwriter Frank Robinson, political consultant Jim Rivaldo, Harvey's aide Anne Kronenberg, and Teamster official Allan Baird. (Photo Rink Foto.)

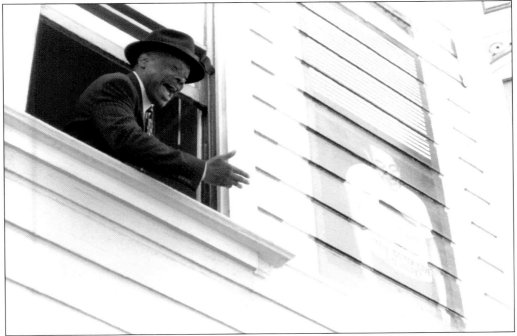

San Francisco mayor Willie Brown looks out the window beside the mural. Mayor Brown and Teamster official Allan Baird spoke at the mural dedication. (Photo Daniel Nicoletta.)

Sister of Perpetual Indulgence Sister Ann R. Key attends a drag bingo benefit for the LYRIC youth program at the Eureka Valley Recreation Center on February 26, 1998. (Photo Rick Gerharter.)

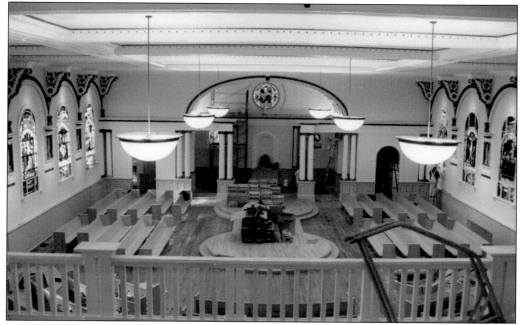

In 1998 Most Holy Redeemer Church carried out extensive remodeling to bring the church into line with reforms suggested by Vatican II. Among other things the sanctuary was remodeled so that the altar juts out into the congregation, with pews surrounding it on three sides. (Photo Most Holy Redeemer.)

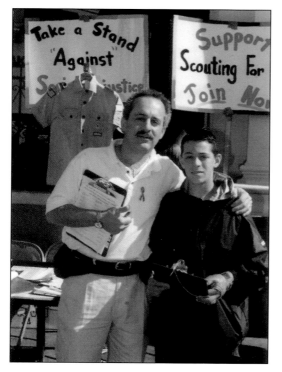

On the right is Steven Cozza with his father Scott, promoting Scouting for All, their organization to end the Boy Scout's exclusion of gay members. According to Rink Foto, Steven is now dating girls and is quite popular with his classmates. His gay advocacy hasn't hurt him. (Photo Rink Foto.)

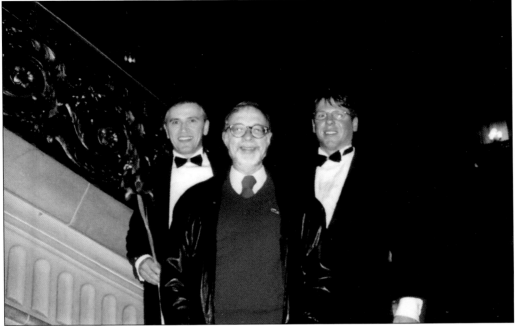

In 1999 Bob Meslinsky (left) and his lover Phil Diers (right) took part in a domestic partner commitment ceremony performed at San Francisco City Hall by Mayor Willie Brown. Hogging the camera in the center is your author. (Photo Robert Meslinsky.)

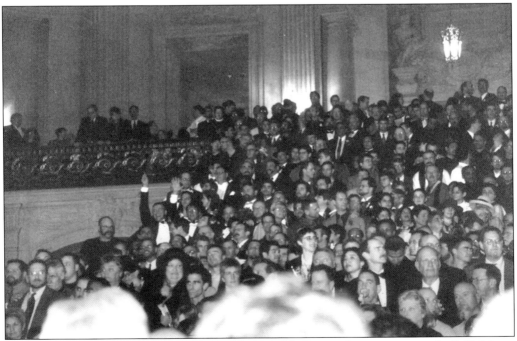

All the gay couples who were married that evening fill the grand staircase at city hall. Bob is on the left with his arm in the air. Phil is next to him. (Photo Robert Meslinsky.)

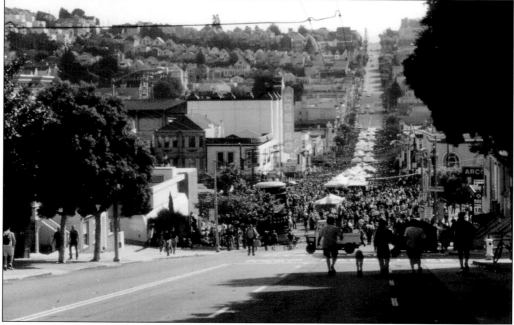

This is the 1999 Castro Street Fair, shot from Castro Street north of Market. (Photo Robert Meslinsky.)

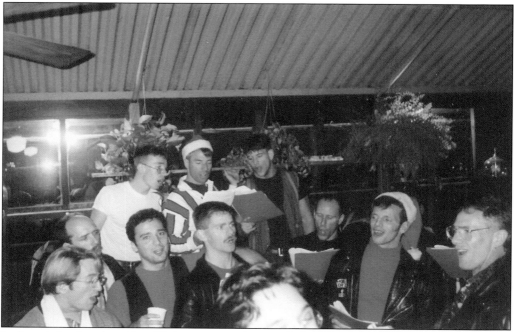

Let's end the decade with a Christmas sing-along at Café Flore. (Photo Daniel Nicoletta.)

Five

2000s

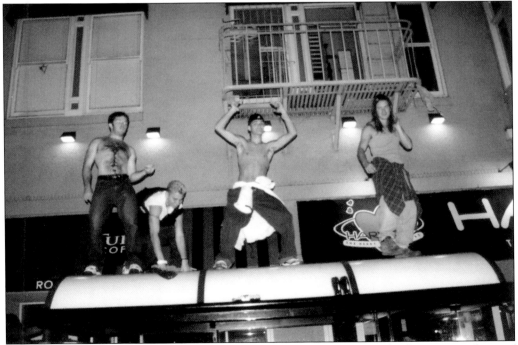

Let's start off the new millennium with young fellows dancing atop the bus stop in front of Harvey's at Eighteenth and Castro. (Photo Robert Meslinsky.)

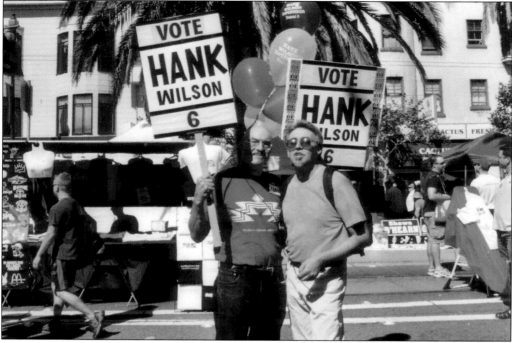

Gilbert Baker (right), creator of the Rainbow Flag, talks with supervisor candidate Hank Wilson at the 2000 Castro Street Fair. (Photo Robert Meslinsky.)

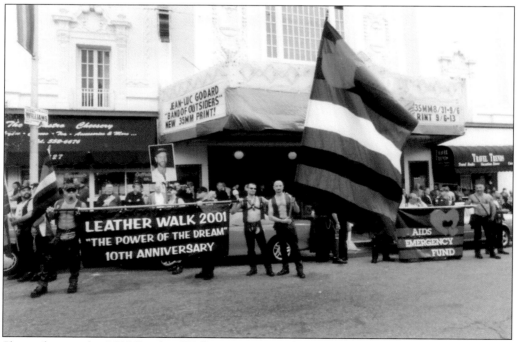

Shown here is the 2001 Leather Walk, an event similar to the AIDS Walk, held each year to raise money for people with AIDS and breast cancer. (Photo Rick Gerharter.)

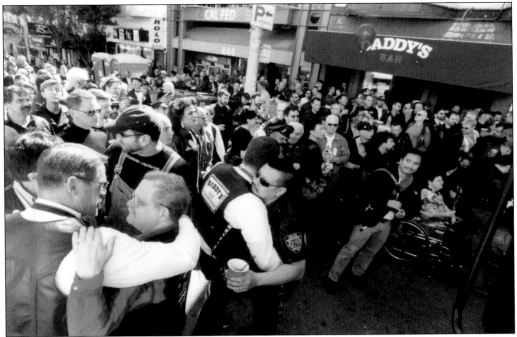

On April 21, 2001 Castro Street was closed off for a party memorializing Philip Turner, owner of Daddy's bar. Philip was a longtime leather activist. (Photo Rick Gerharter.)

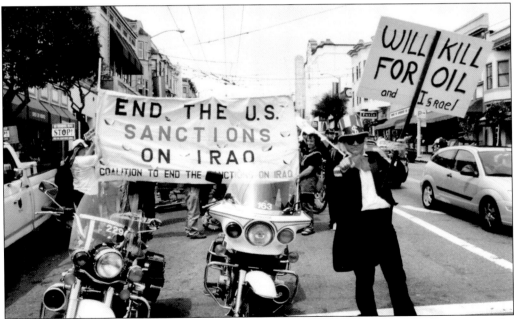

This picture represents the scores of protest marches that have arisen in the Castro over the past 30 years. This is the only march done twice for two different President Bushes. (Photo Robert Meslinsky.)

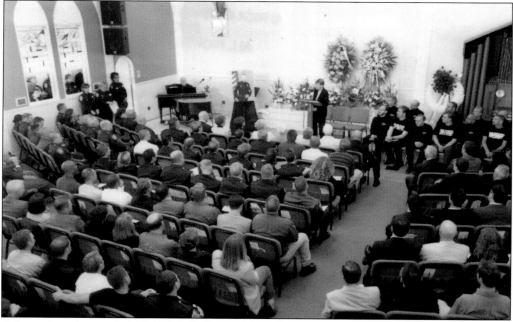

A funeral service was held June 15, 2002, at Metropolitan Community Church, for Jon Cook, the first openly gay San Francisco police officer killed in the line of duty. (Photo Rick Gerharter.)

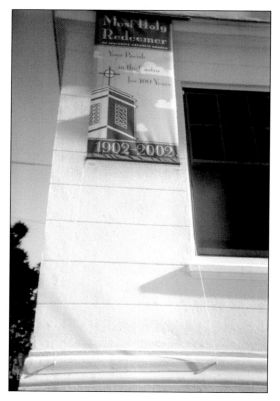

In 2002 Most Holy Redeemer celebrated the centennial of its consecration. Right under "Most Holy Redeemer" on the banner hanging on the side of the rectory are the words, "An Inclusive Catholic Church." (Photo Strange de Jim.)

This is Father Donal Godfrey and a parishioner outside Most Holy Redeemer. Father Donal is wearing rainbow vestments made for him by another parishioner. Father Donal wrote his doctoral dissertation on "The Gays and the Grays" at Most Holy Redeemer and has been most helpful in preparing this book. (Photo Fr. Donal Godfrey.)

Harry Hay celebrates his 90th birthday with his lover John Burnside at the GLBT Community Center April 7, 2002. Harry co-founded the Mattachine Society, the first national gay rights organization, in Los Angeles in 1948. He lived his last years in the Castro and was active in the Radical Faeries. He died shortly after this photo was taken. (Photo Rick Gerharter.)

Three Sisters of Perpetual Indulgence pose in the auditorium of the Castro Theatre at the May 10, 2002, opening of The Cockettes movie. (Photo Rick Gerharter.)

Julie Newmar, Catwoman to Adam West's Batman, appeared at a 2002 benefit for the Gay Men's Chorus at the Castro Theatre. Shown here, from left to right, are Supervisor Mark Leno, chorus conductor Kathleen McGuire, chorus executive director Scott Mandell, Julie Newmar, and her brother Dr. John Newmeyer. (Photo Rink Foto.)

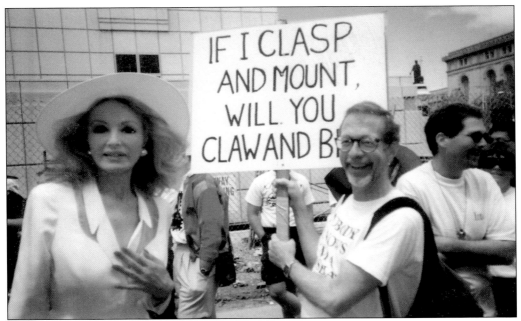

The author is pictured with Julie Newmar, at an earlier GLBT Parade, where she led the "Gay Cat Lovers of America" contingent. The author is holding Julie's brother's sign. (Photo Strange de Jim.)

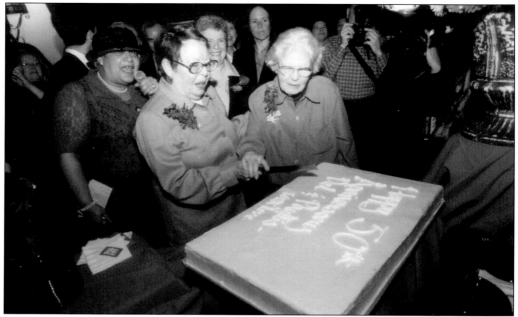

Legendary lesbians Del Martin, left, and Phyllis Lyon celebrated their 50th anniversary at the Castro Theatre opening of *No Secrets Anymore*, the documentary about their lives, on February 13, 2003. (Photo Rick Gerharter.)

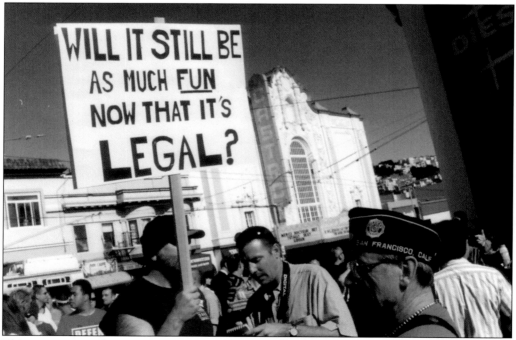

This spontaneous demonstration arose at Harvey Milk Plaza at the corner of Castro and Market, on June 26, 2003, when the United States Supreme Court reduced sodomy to the misdemeanor charge of "following too closely." (Photo Rick Gerharter.)

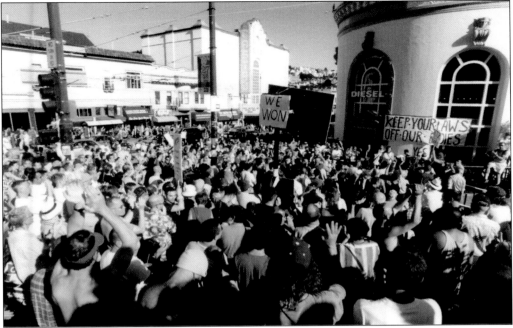

It's like old times: Something happens, everyone gathers. (Photo Rick Gerharter.)

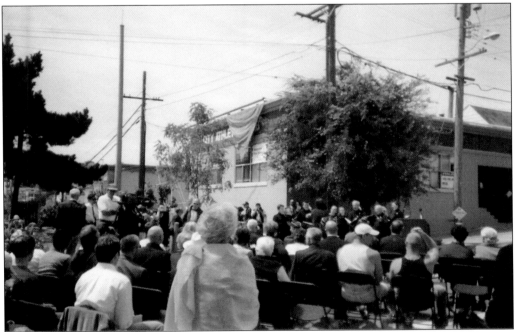

In July 2003 a memorial plaque and small park dedicated to the gay victims of the Holocaust was dedicated in the little triangle between Market and Seventeenth Streets just west of Castro. (Photo Strange de Jim.)

Here are a few of the people interviewed for this book. On the left is Todd Trexler, the artist who opened the Peaches Dream Galleries at 584B Castro. Today Todd is a nurse. On the right is Tory Hartmann, close friend and ally of Harvey Milk. Today she runs her family's company on the Peninsula. (Photos Todd Trexler and Strange de Jim.)

Pictured here are Teamster official Allan Baird, left, close friend and associate of Harvey Milk, and John Ryckman, Harvey's campaign manager in his bid for the state assembly. Today they are both very actively retired. (Photos Strange de Jim.)

Six

TODAY

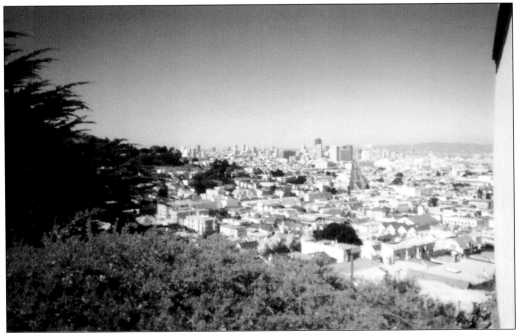

This is the view from Kite Hill in 2003, where several of the oldest photos of the Castro were taken. We can still see Market Street running straight to the San Francisco Bay. Just to the right of the near end of Market is the Castro Theatre. (Photo Strange de Jim.)

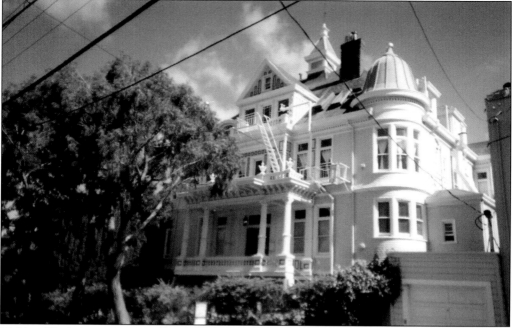

Nobby Clarke's mansion still exists, but it has been broken up into apartments. (Photo Strange de Jim.)

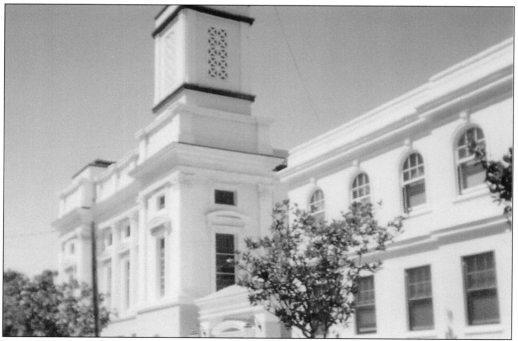

Pictured here is the Most Holy Redeemer as it looks today. Notice that there is only one tower. The missing tower survived the 1906 earthquake, but toppled in the 1957 tremor. (Photo Strange de Jim.)

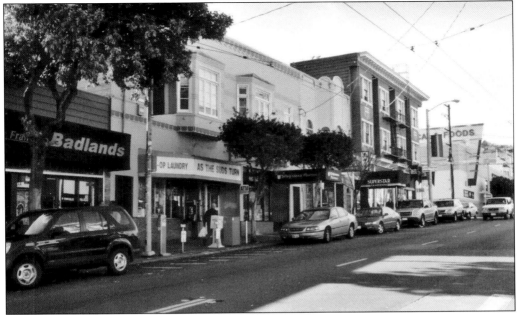

This is a view of Eighteenth Street west of Castro, from Badlands bar to Cala Foods, which occupies the spot where Heinecke Brothers once stood. (Photo Robert Meslinsky.)

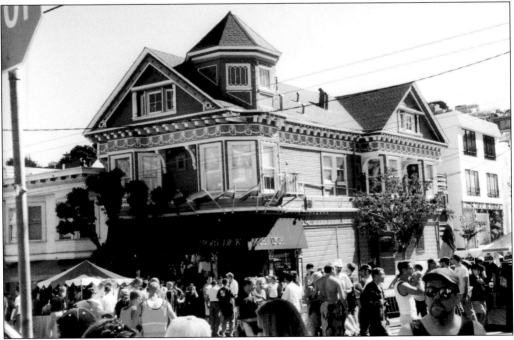

Moby Dick bar is shown here on Eighteenth and Hartford, east of Castro Street. Its whale of an aquarium may explain its name. (Photo Robert Meslinsky.)

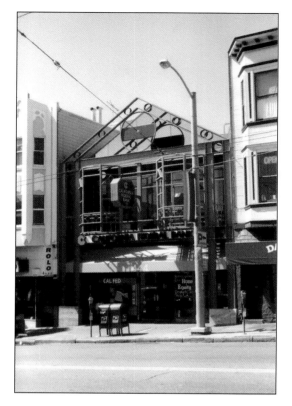

On the west side of Castro between Eighteenth and Market, California Federal Bank has changed to a façade very different from the surrounding buildings. This is a 2001 photo. It is now Citibank. (Photo Robert Meslinsky.)

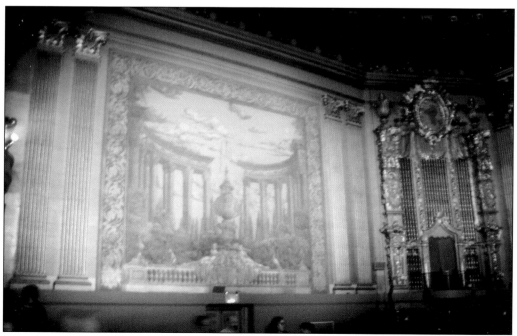

The restored Castro Theatre still features wonderful murals. (Photo Robert Meslinsky.)

The organist at the Castro Theatre still plays a few songs before the movie, always ending with "San Francisco." (Photo Robert Meslinsky.)

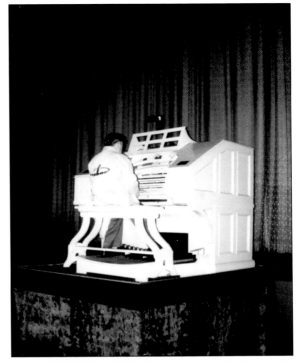

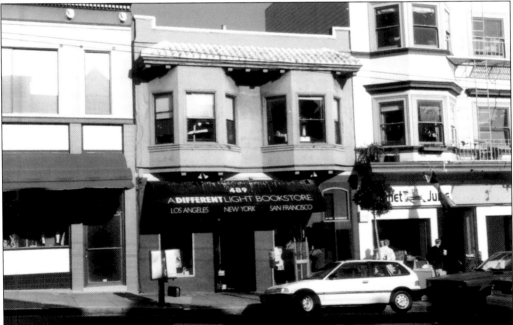

A Different Light, a small gay bookstore chain, was started in Los Angeles in 1979. Richard Labonte opened the San Francisco store in 1987. It was the headquarters for ACT-UP, Queer Nation, and other groups, and hosted about 20 events every month. It has been under new ownership for the past couple of years. (Photo Robert Meslinsky.)

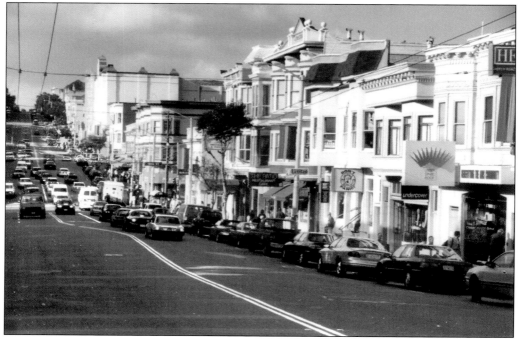

Here is the east side of the two main blocks of Castro. (Photo Robert Meslinsky.)

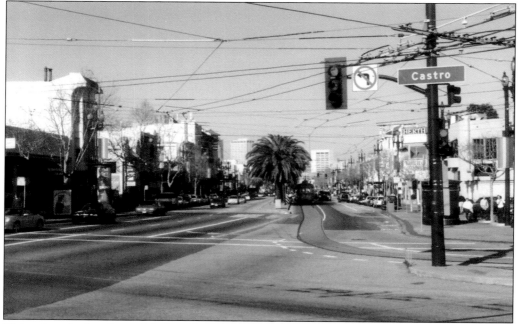

This view looks down Market Street from the corner of Castro and Market. (Photo Robert Meslinsky.)

The F Line features vintage streetcars from around the world and runs down Market to the Ferry Building and then along the Bay to Fisherman's Wharf. This car is from Milan, Italy. (Photo Robert Meslinsky.)

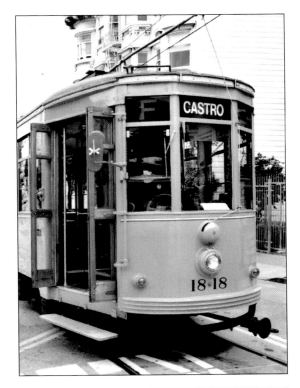

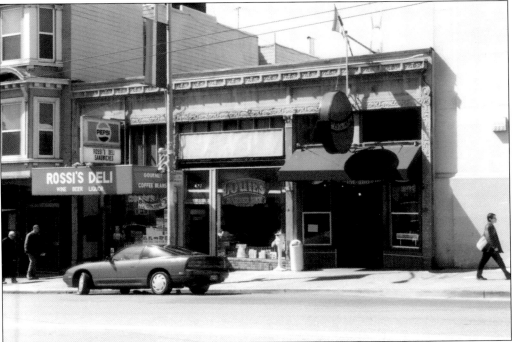

On the west side of Castro just below Market we see three longtime businesses: Marcello's Pizza, Louie's Barber Shop (since 1947), and Rossi's Deli. (Photo Robert Meslinsky.)

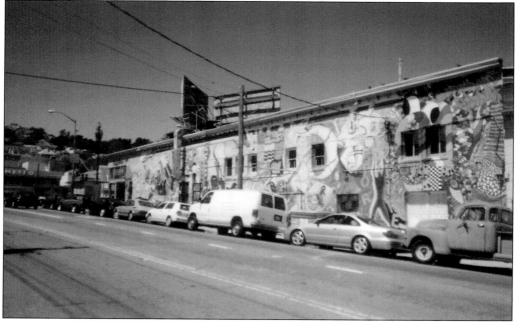

This mural decorates the back of the Bagdad Café, just across Sixteenth street from the Harvey Milk Branch of the San Francisco Public Library. (Photo Strange de Jim.)

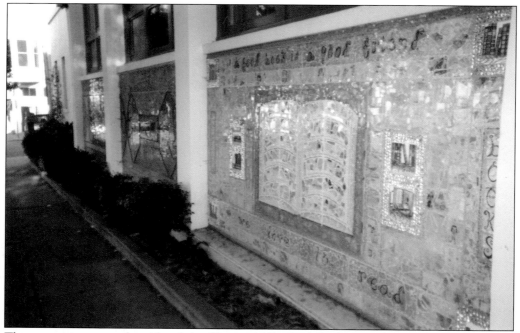

These mosaics grace the side of the Harvey Milk Civil Rights Academy, formerly Douglass School, on Nineteenth at Collingwood. The name was changed in 1996 after heated debate. Today the school has 250 students, grades K-5, and teaches tolerance and non-violence, celebrating diversity. (Photo Strange de Jim.)

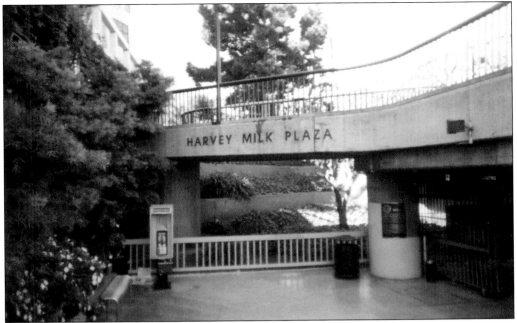

As we saw from the U.S. Supreme Court sodomy ruling event, people still gather at Harvey Milk Plaza, the Muni underground station at Castro and Market, for demonstrations and celebrations. (Photo Strange de Jim.)

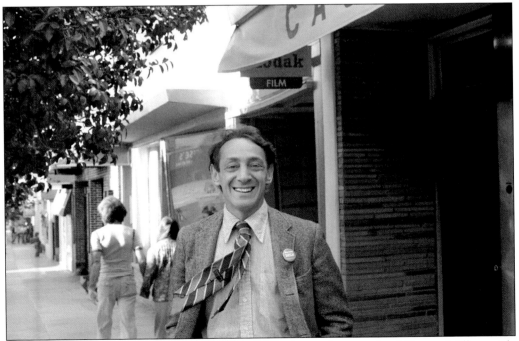

No Castro history would be complete without this classic photograph of Harvey Milk outside his camera store. (Photo Daniel Nicoletta.)

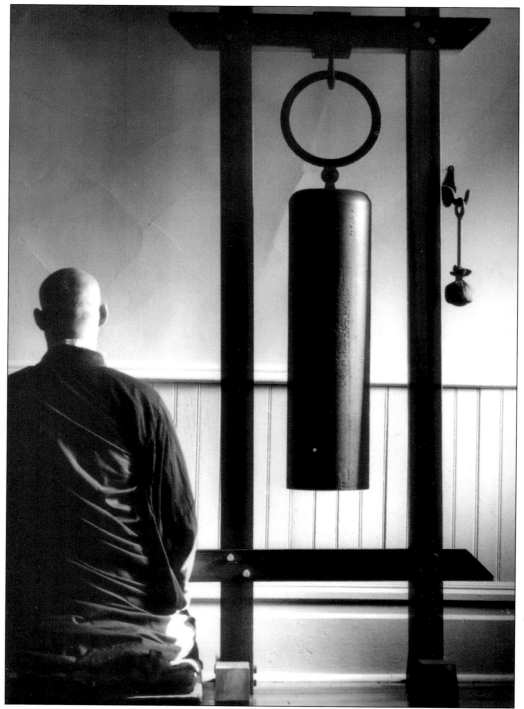

Let's end with this quiet masterpiece showing the late monk Joshi meditating at the Hartford Street Zen Center. Go in peace. See you at http://members.aol.com/strangecastro. (Photo Rick Gerharter.)